WELCOME! We hope you enjoy this Fave Art-13 album collection of Classis Nude Art (Statues & Paintings). Most art works are copied from the internet, posters, pictures and books. Most are collector's items and can be seen in famous galleries and private homes. The originals are very expensive but copies are available from some dealers. You may display this book as coffee table book in your living room, as conversation piece. You may give this as gift. You may cut out and frame each page. Each art work is 8.5x11 inches and suitable for framing, and for wall decors.

The ISBN Code Numbers of this book are:
ISBN-13: 978- 1547179671 & ISBN-10: 1547179678
Printed in USA. Free to copy by anybody. Why copy? Just buy the book.
My other books list can be accessed at:
http://tinyurl.com/mj76ccq & http://www.jobelizes6.wix.com/mysite.
My contact email is job_elizes@yahoo.com. (Tatay Jobo Elizes, Pub.)

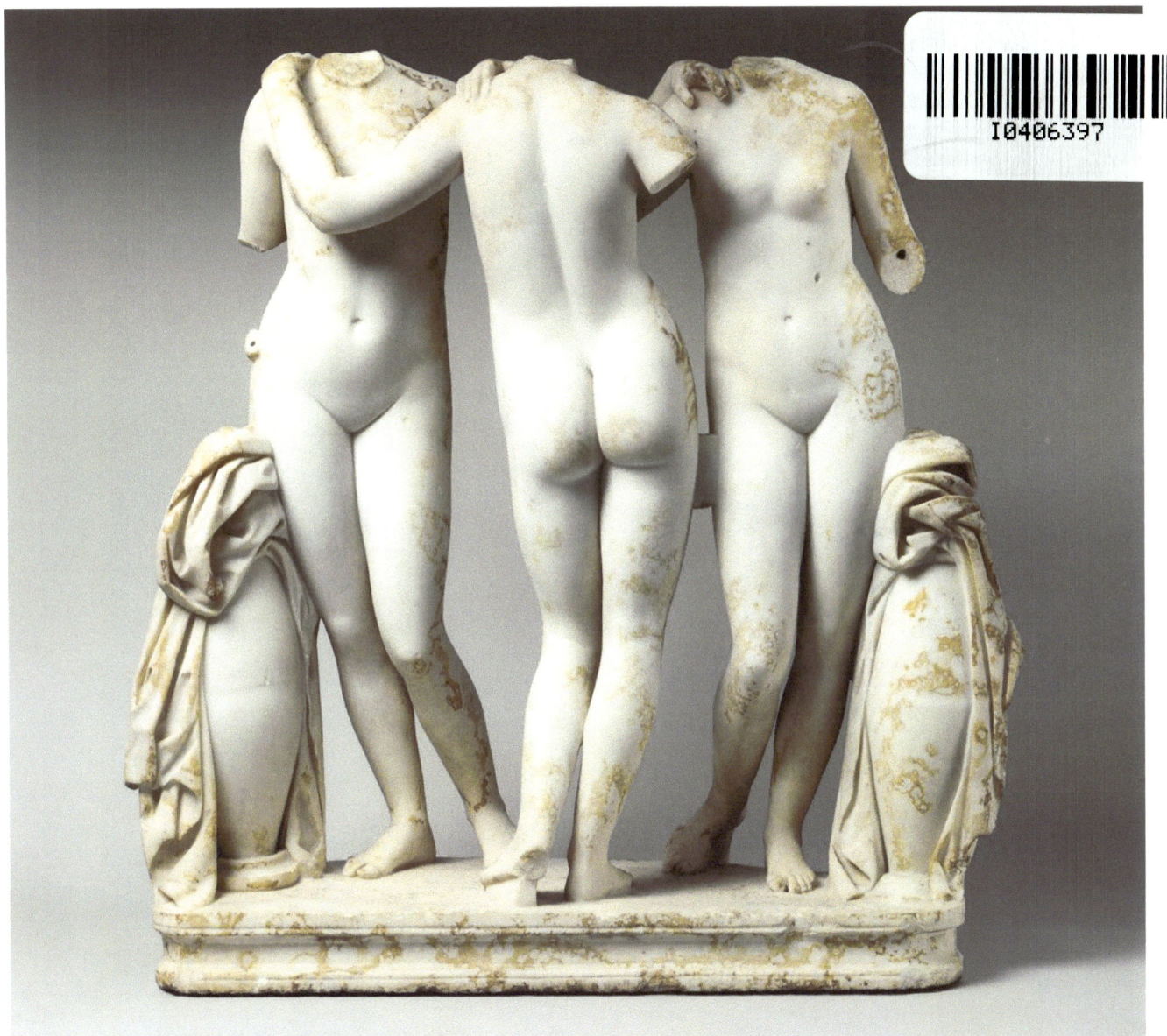

Marble Statue of the Three Graces. Greek

Victory over life by Dr. Jose Rizal, gift to Dr. Blunebtritt

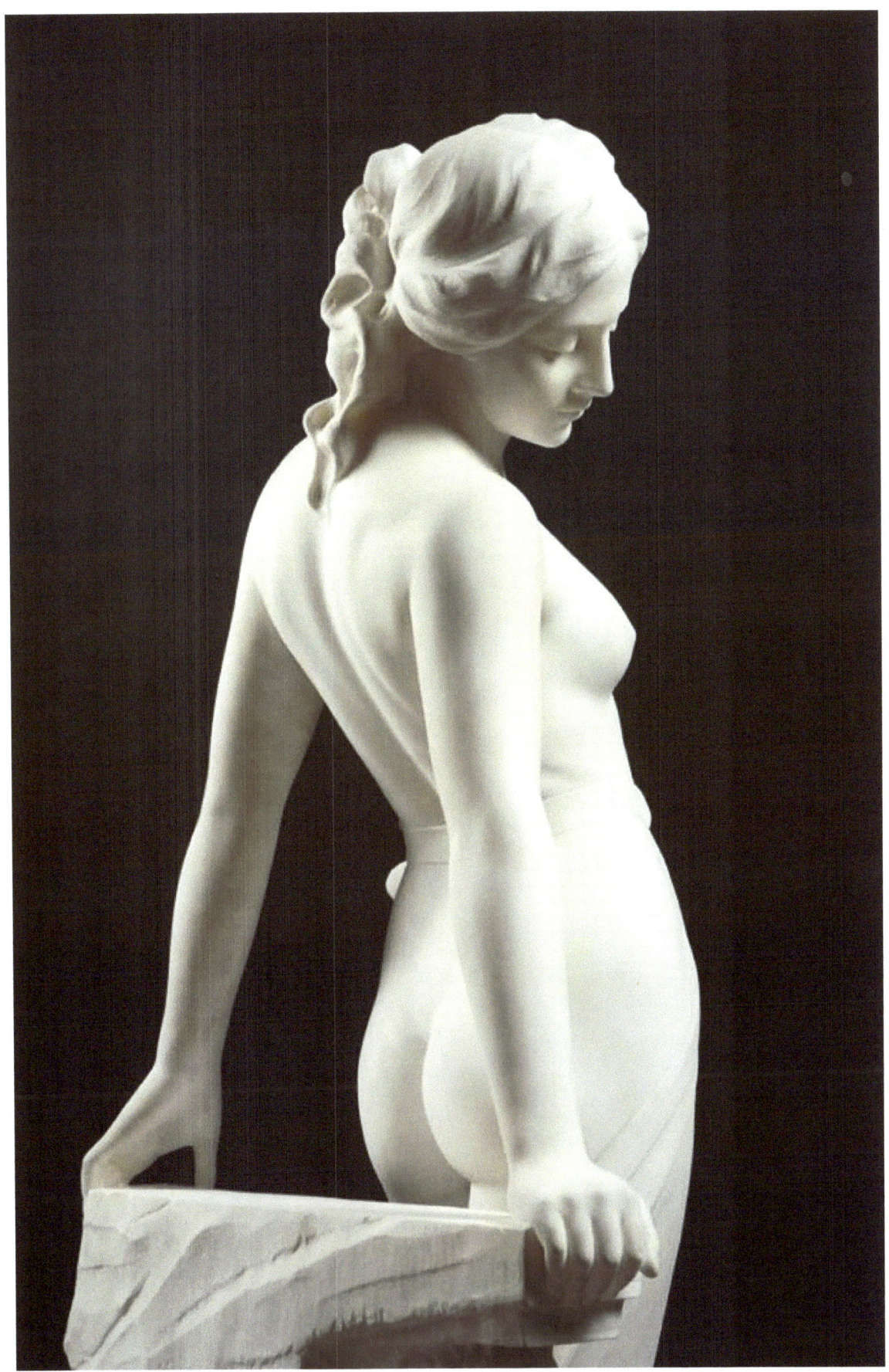

Statue in Rome by Emilio Fiaschi, 1858-1941

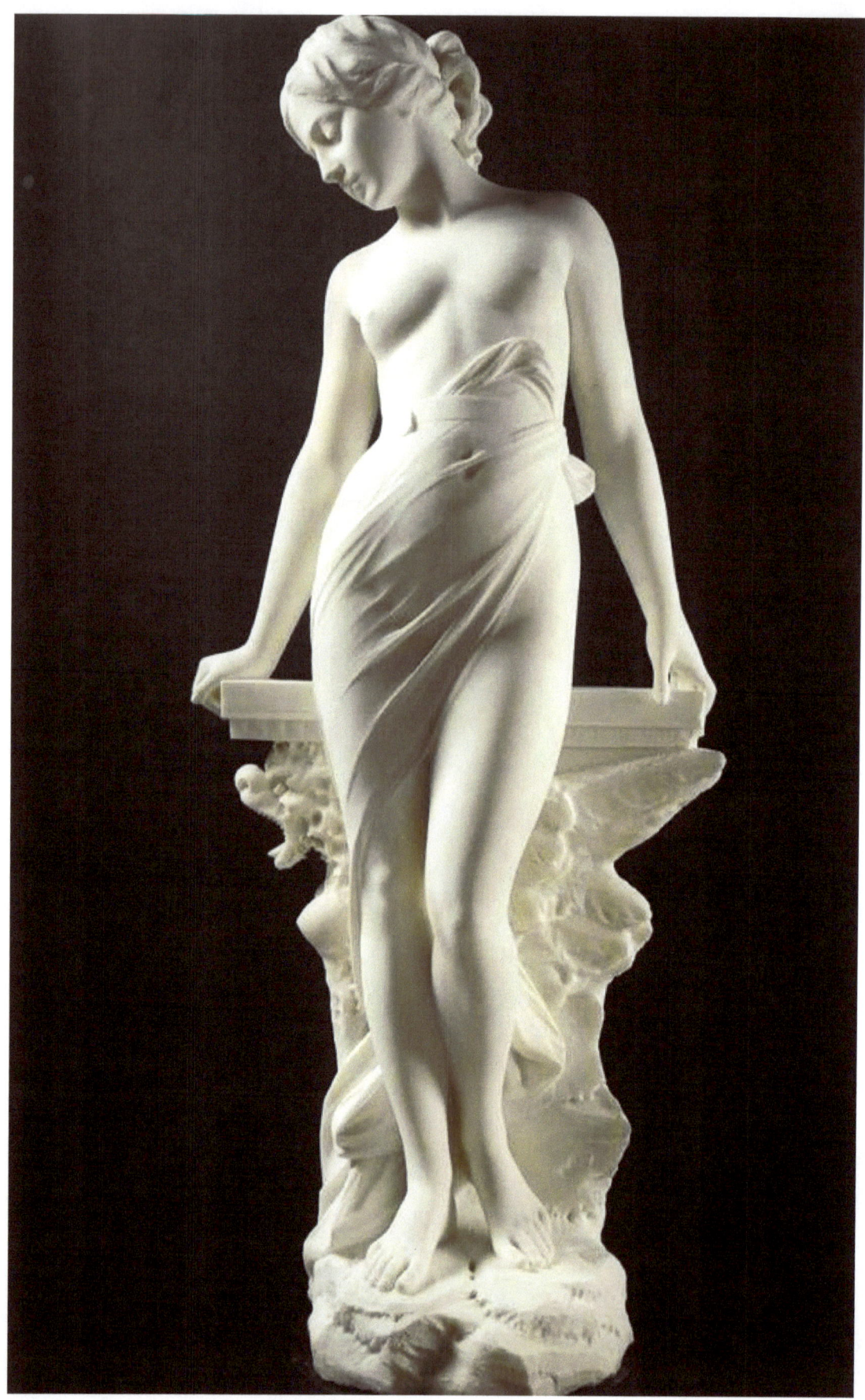

By Emilio fiaschi, marble

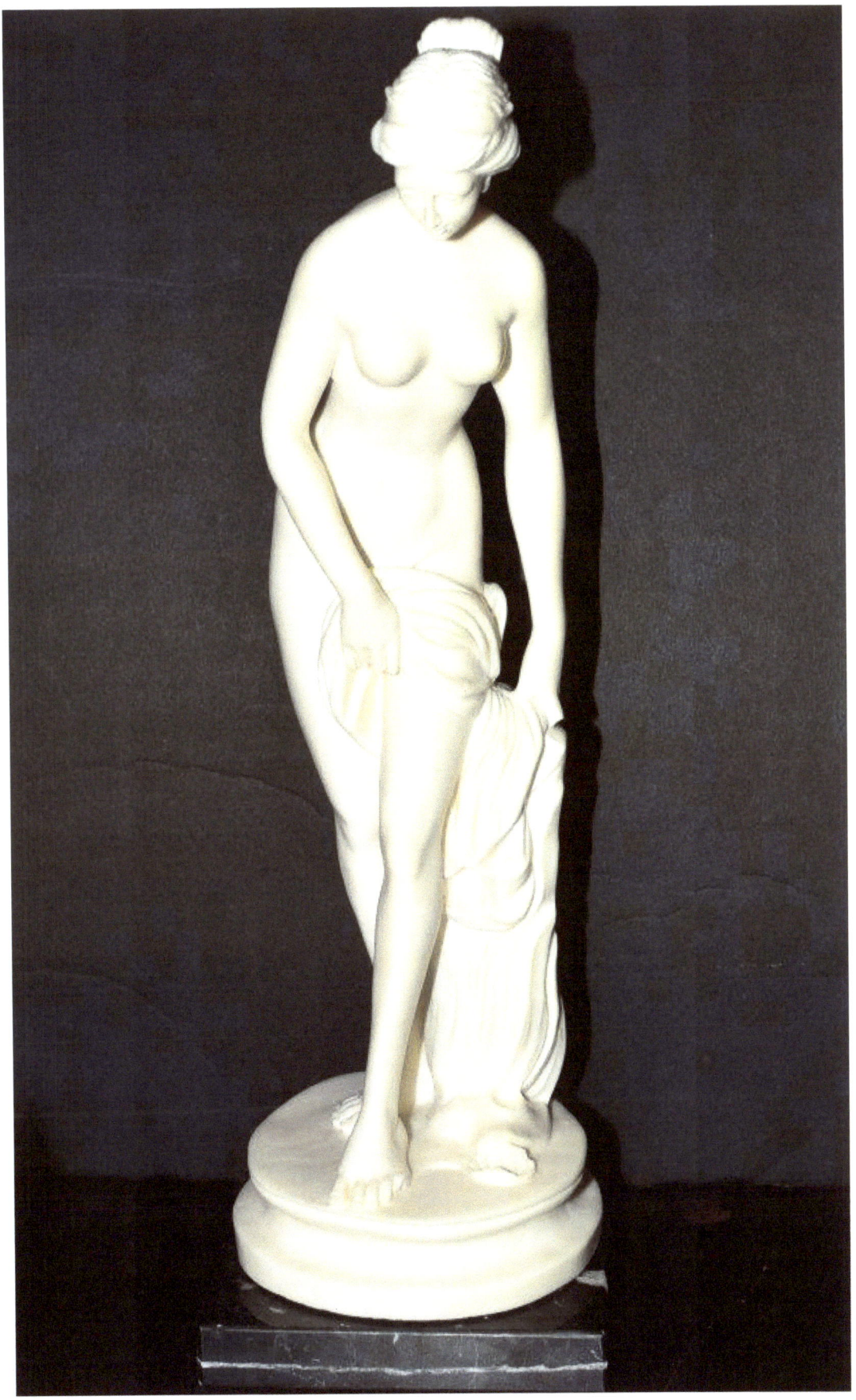

A.Santini, nude bathing

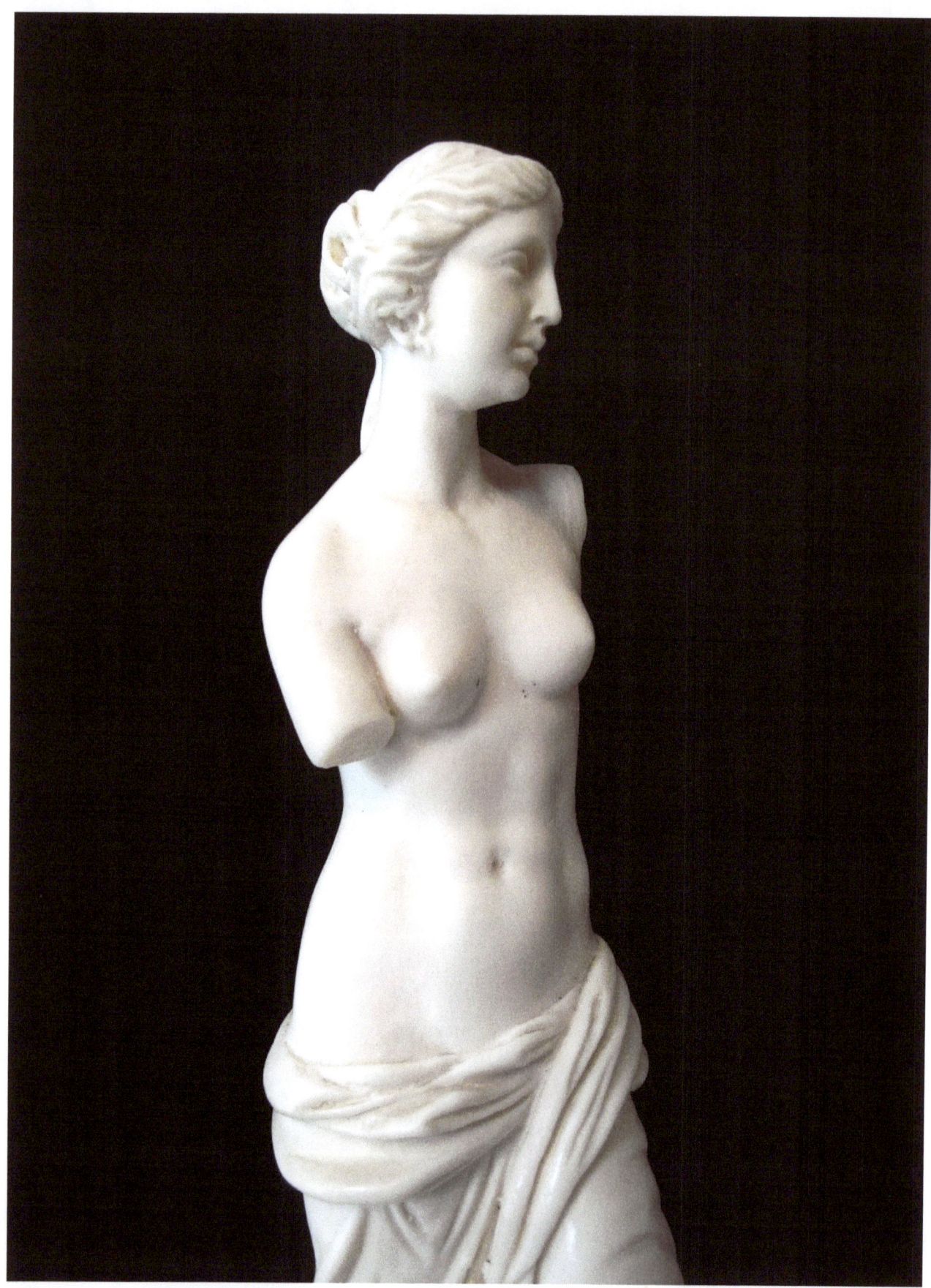

A.Santini

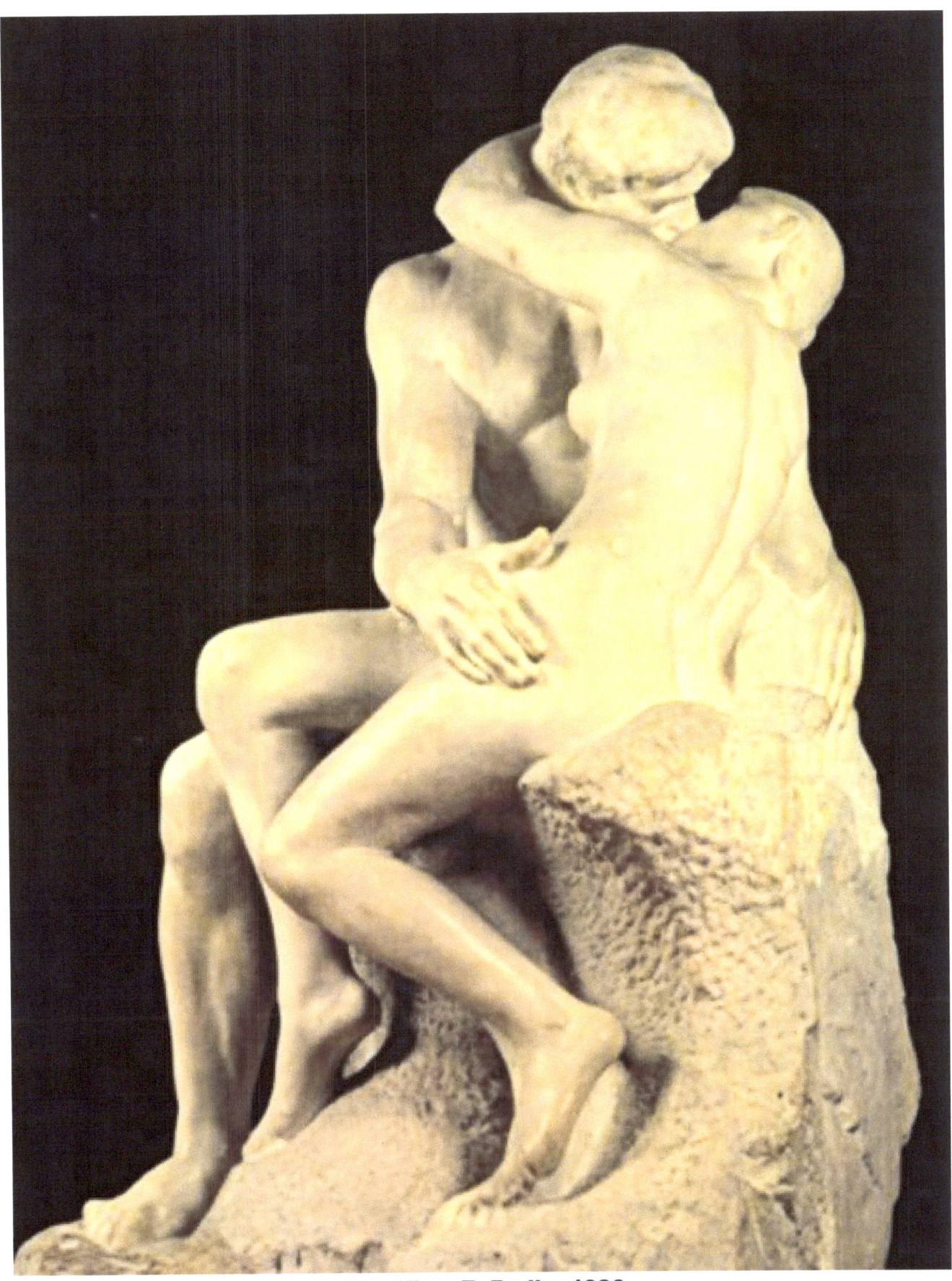

The Kiss, E. Rodin, 1886

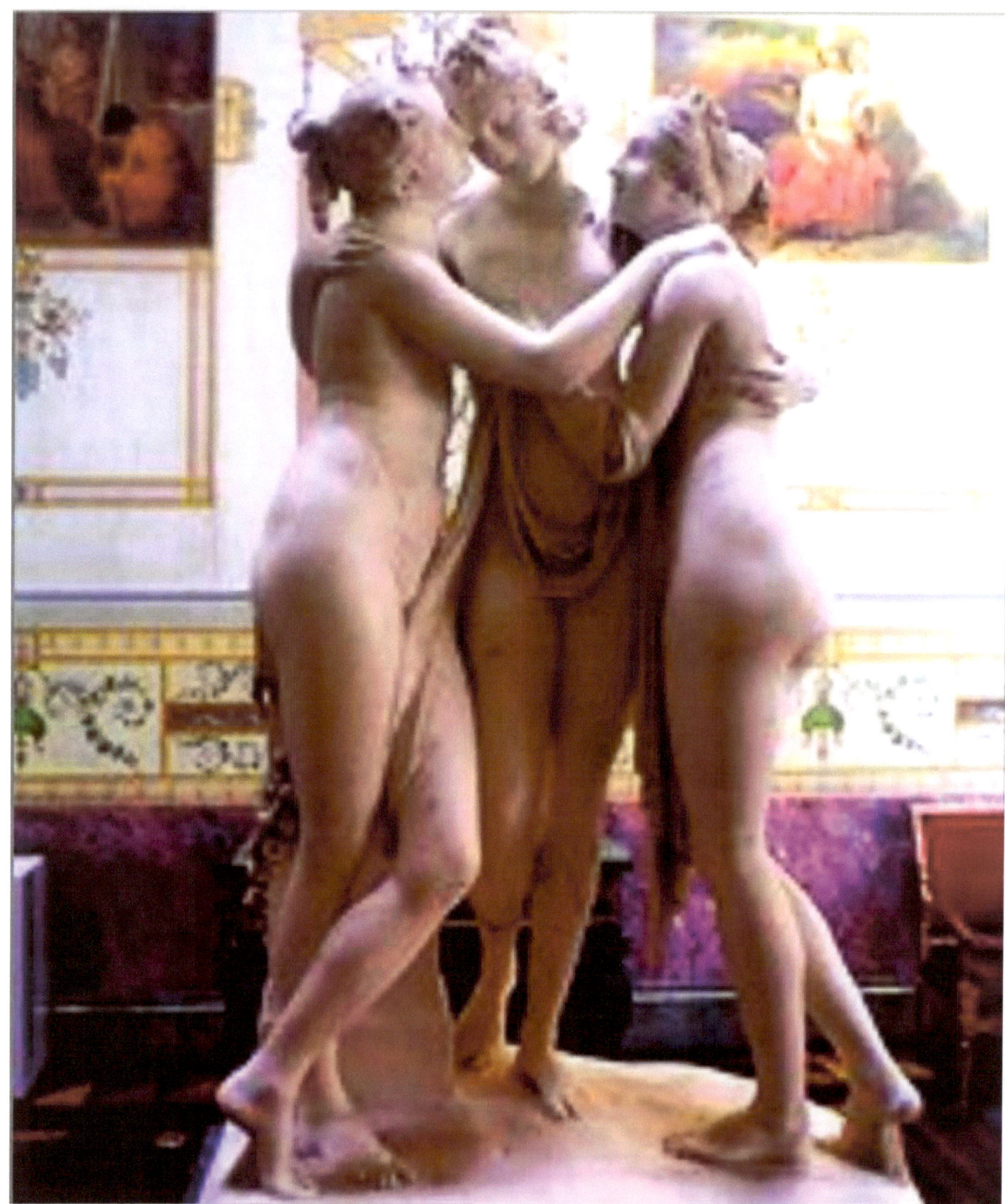

The three graces, 1913, Antonio Canova

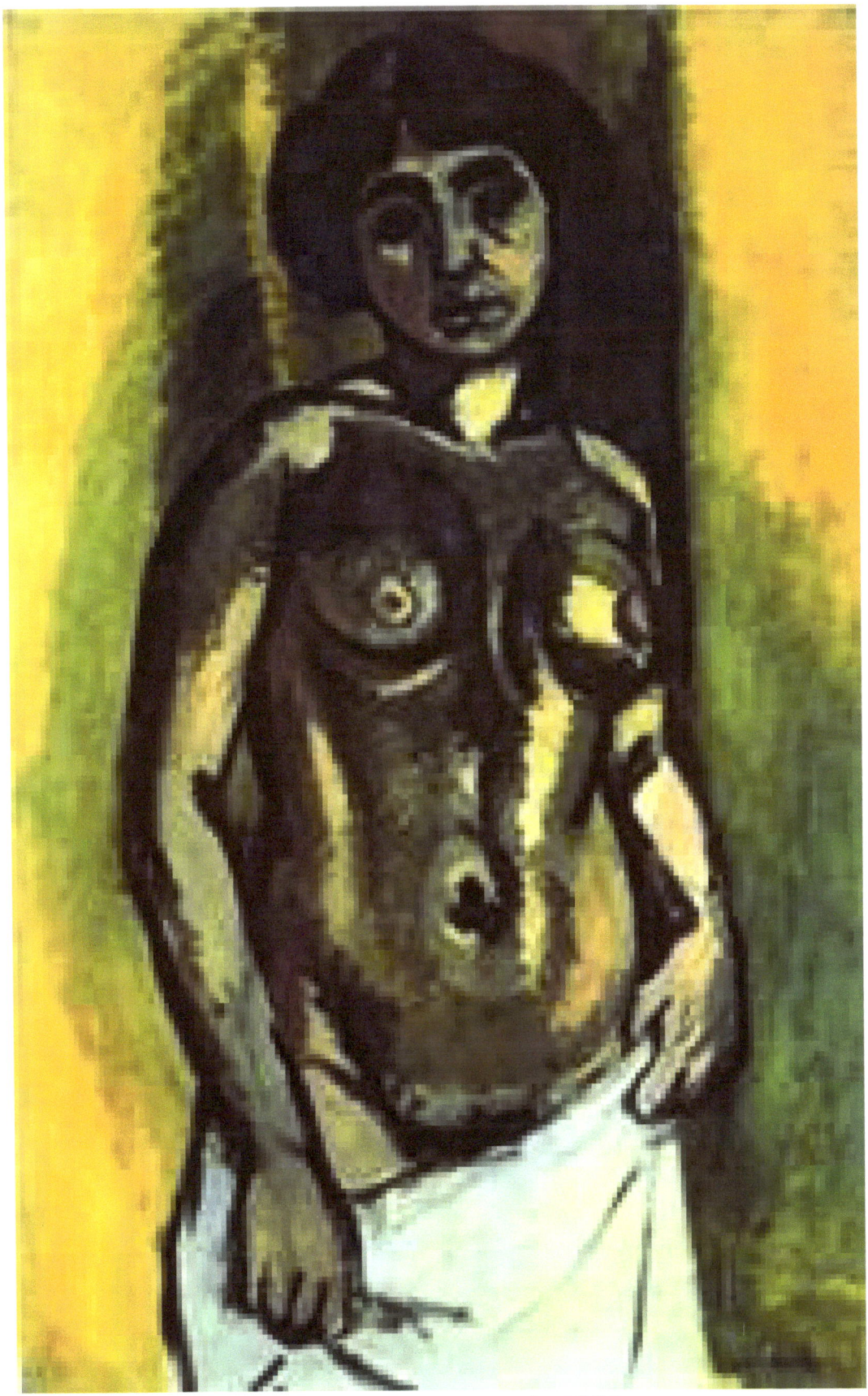

Nude, by Matisse, early 1900s

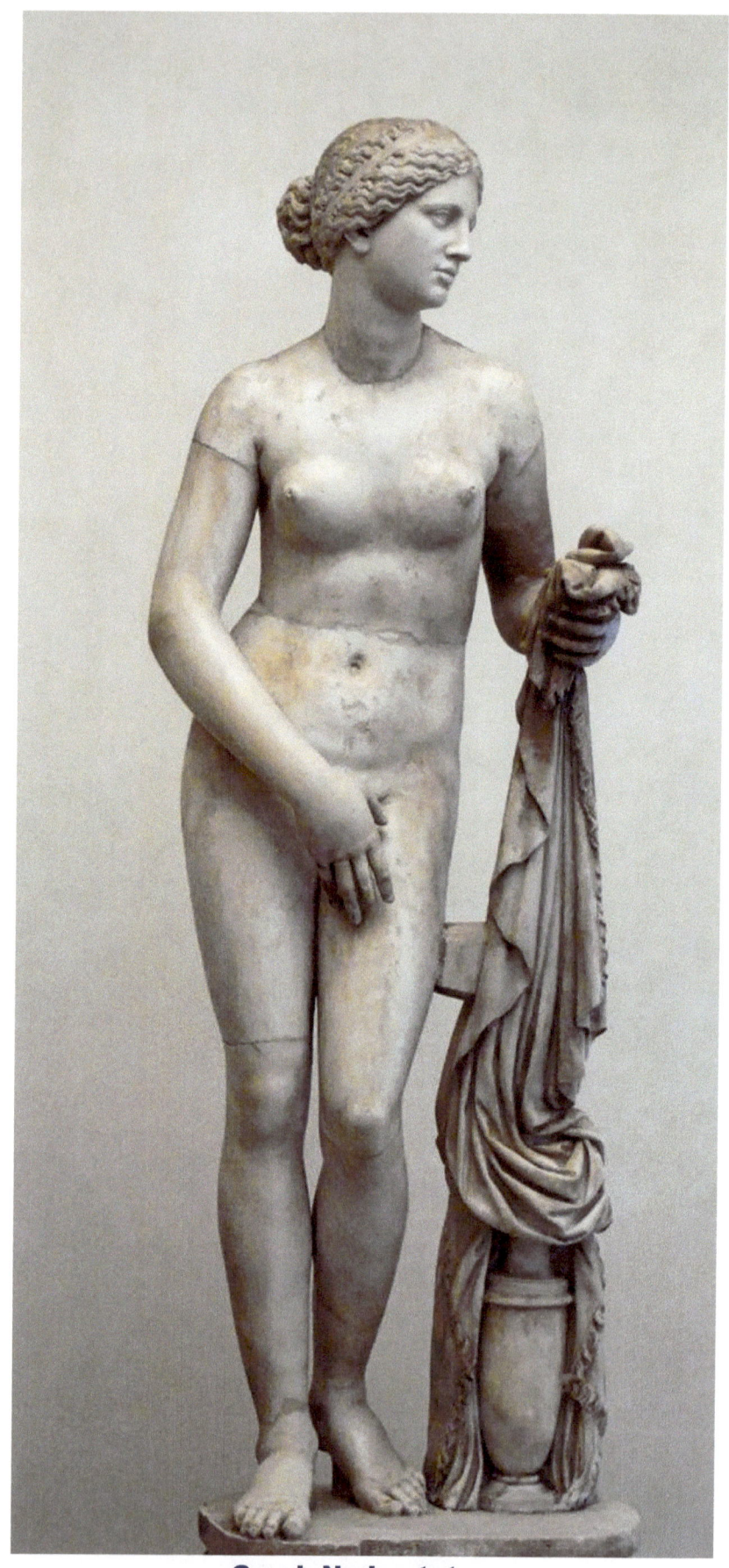

Greek Nude statue

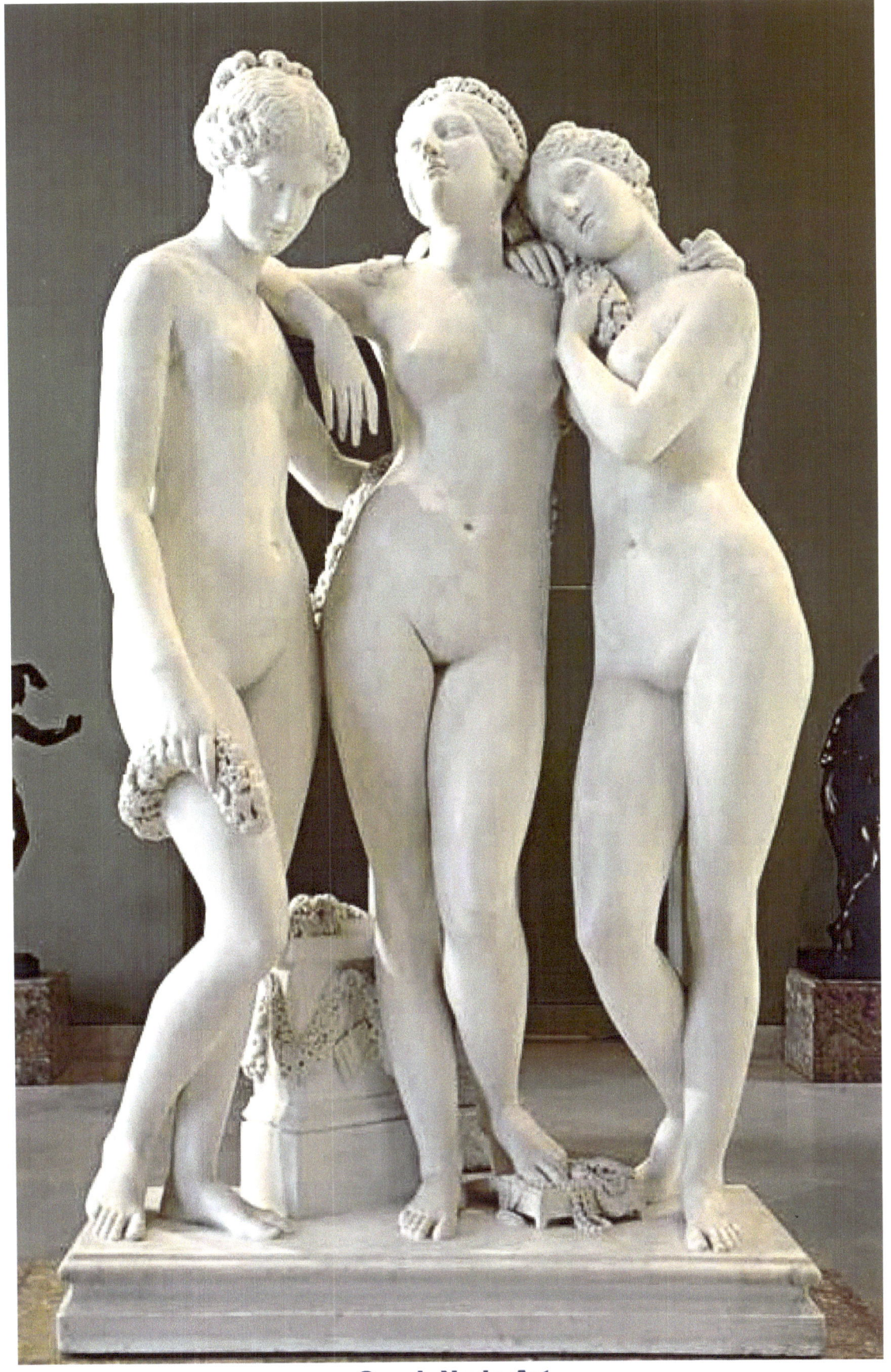

Greek Nude Art

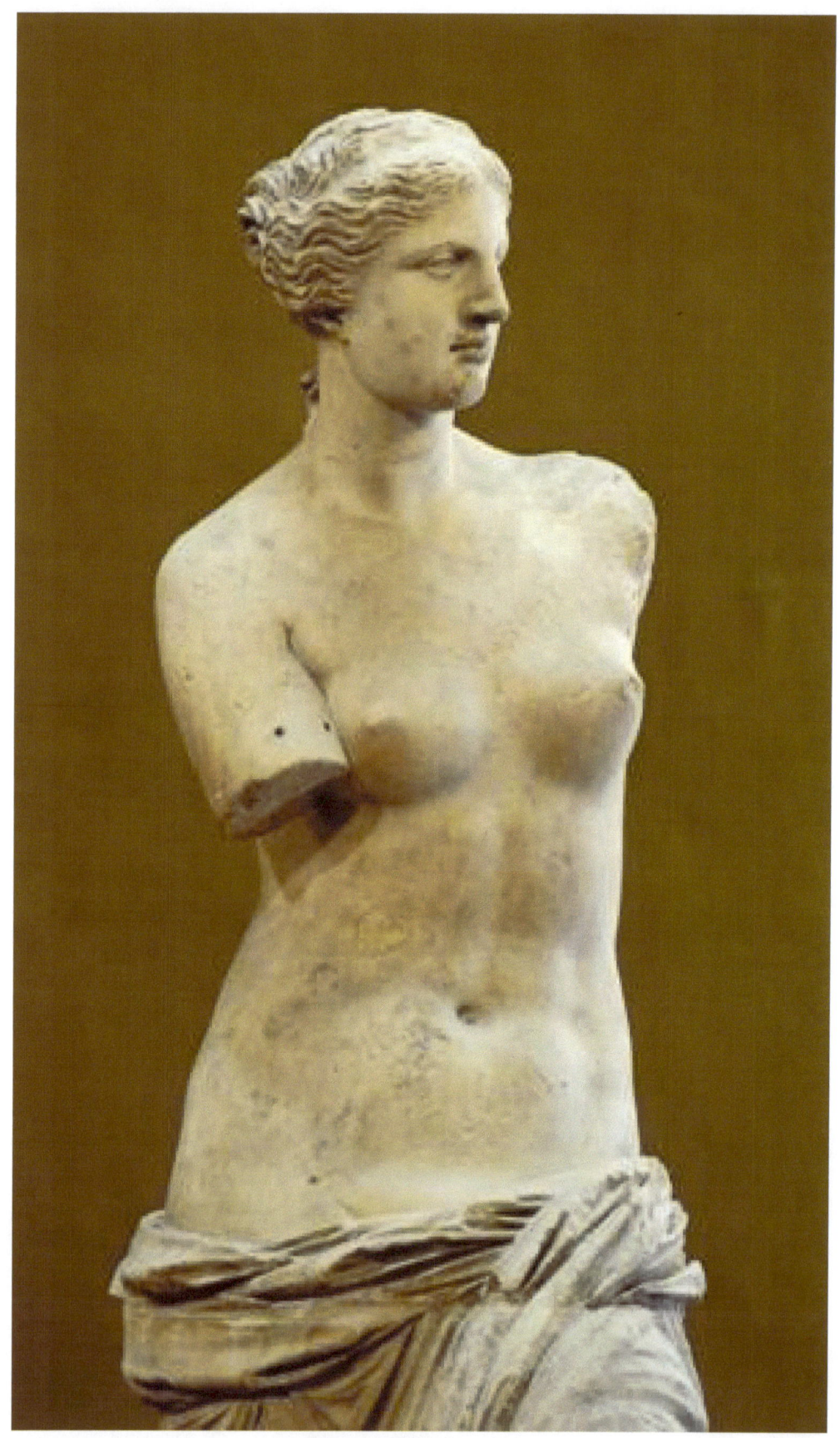

Greek Nude Art

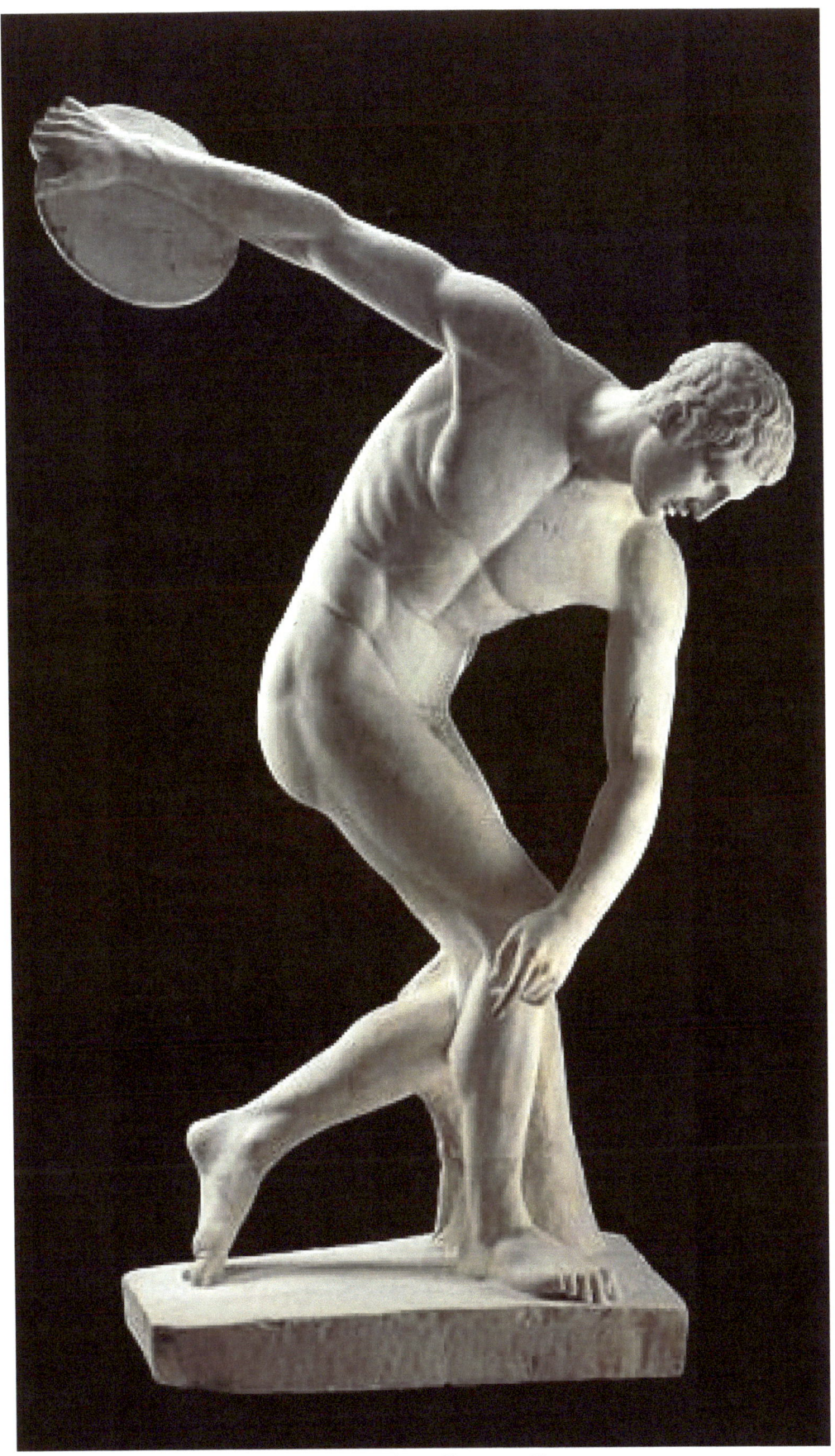

Discobolos, the discus thrower

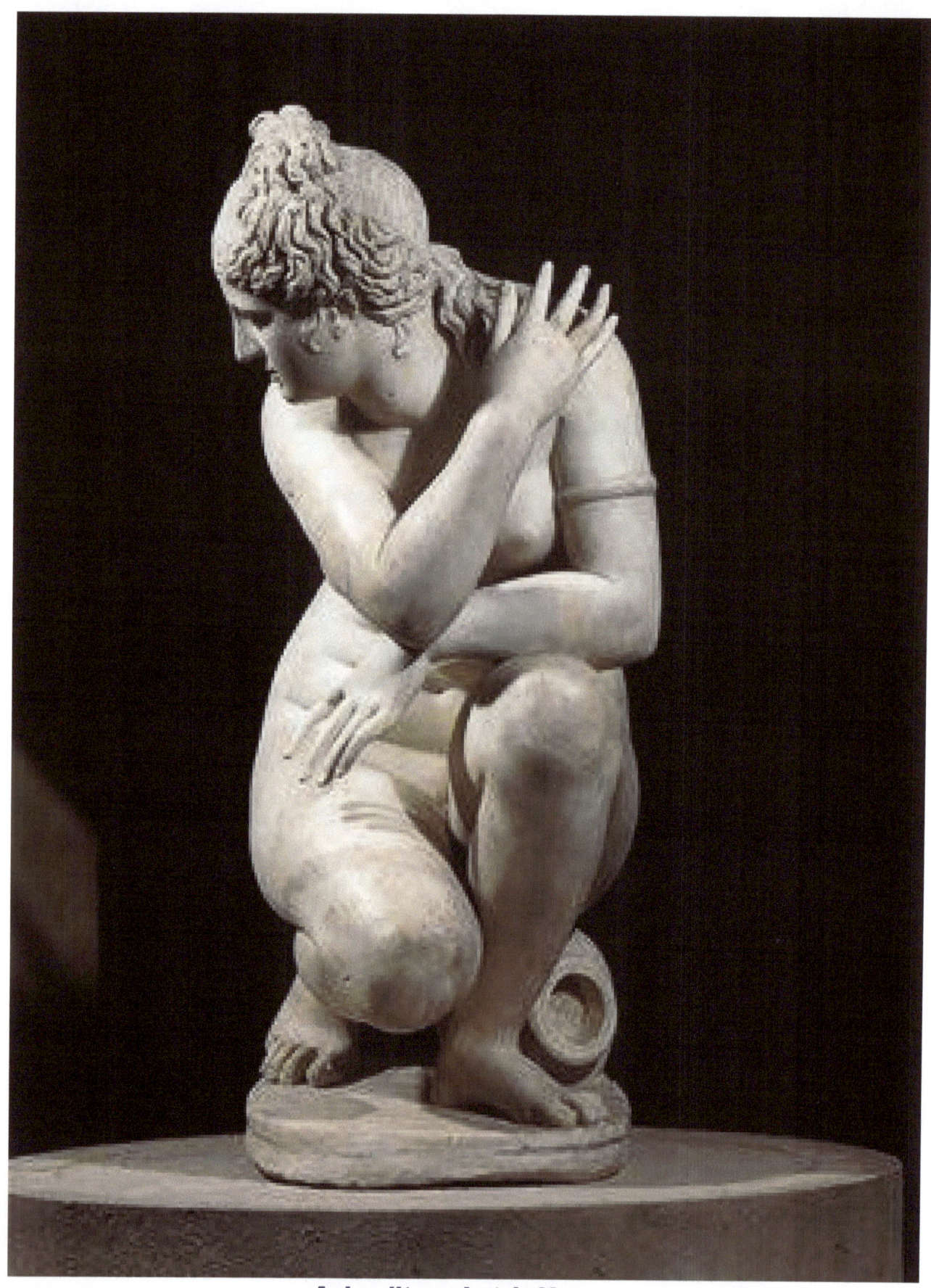

Aphrodite or Lety's Venus

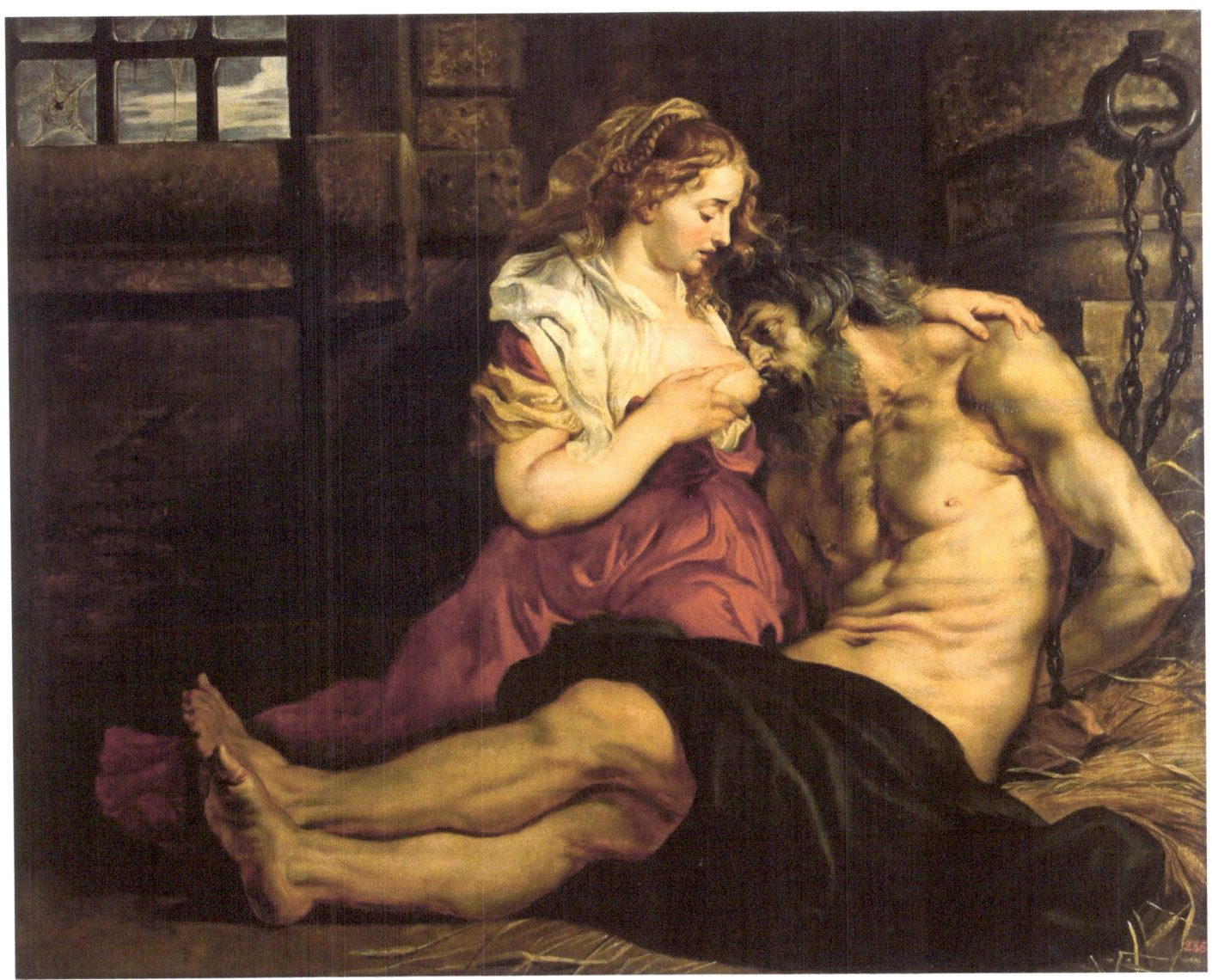

1575, by Paolo Geronese, early renaissance painting

WELCOME! We hope you enjoy this Fave Art-13 album collection of Classis Nude Art (Statues & Paintings). Most art works are copied from the internet, posters, pictures and books. Most are collector's items and can be seen in famous galleries and private homes. The originals are very expensive but copies are available from some dealers. You may display this book as coffee table book in your living room, as conversation piece. You may give this as gift. You may cut out and frame each page. Each art work is 8.5x11 inches and suitable for framing, and for wall decors.

The ISBN Code Numbers of this book are:

ISBN-13: 978- 1547179671 & ISBN-10: 1547179678

Printed in USA. Free to copy by anybody. Why copy? Just buy the book.

My other books list can be accessed at:

http://tinyurl.com/mj76ccq & http://www.jobelizes6.wix.com/mysite.

My contact email is job_elizes@yahoo.com. (Tatay Jobo Elizes, Pub.)

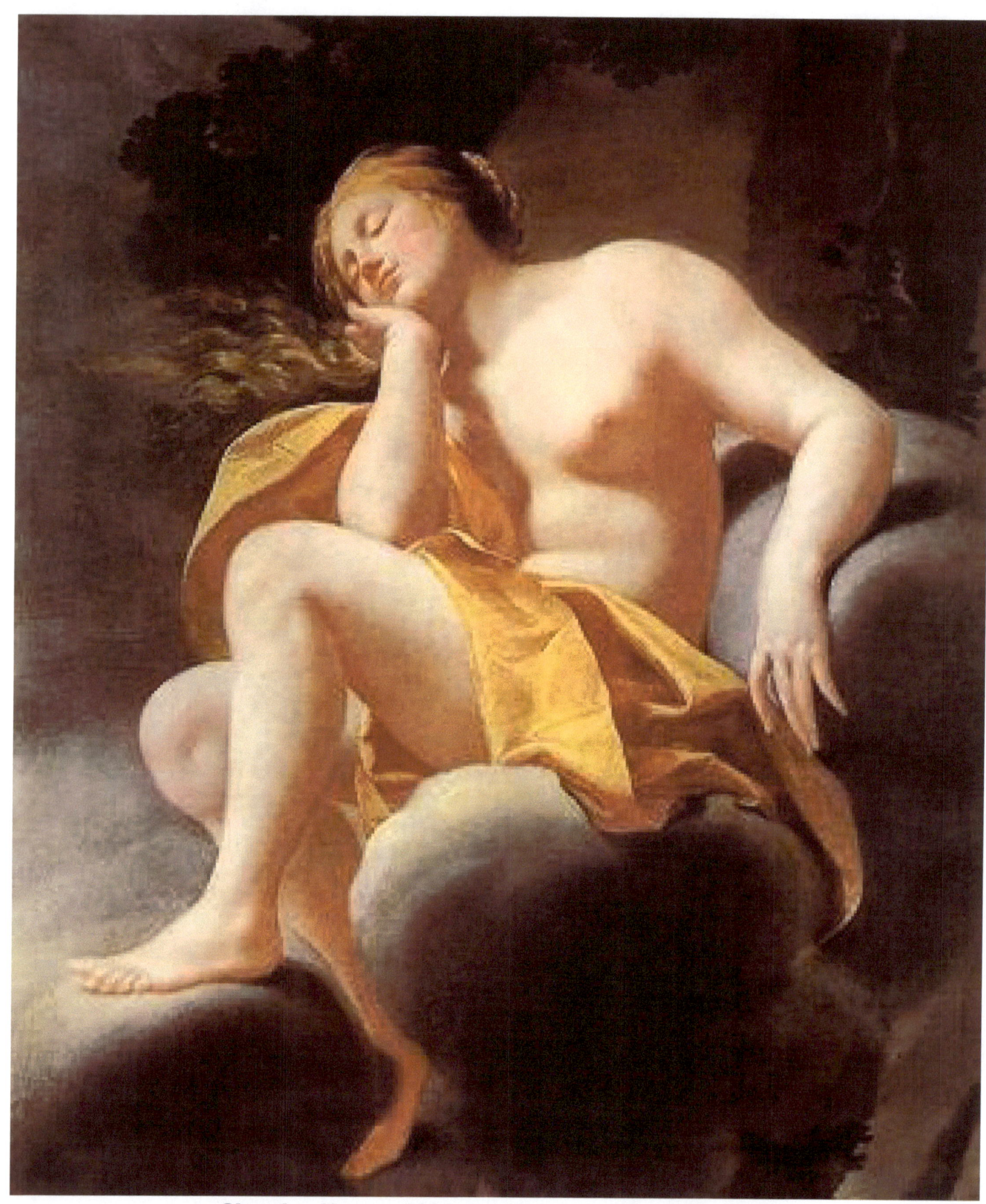

Sleeping Venus, 1630, by Simon Vouet, 1590-1649

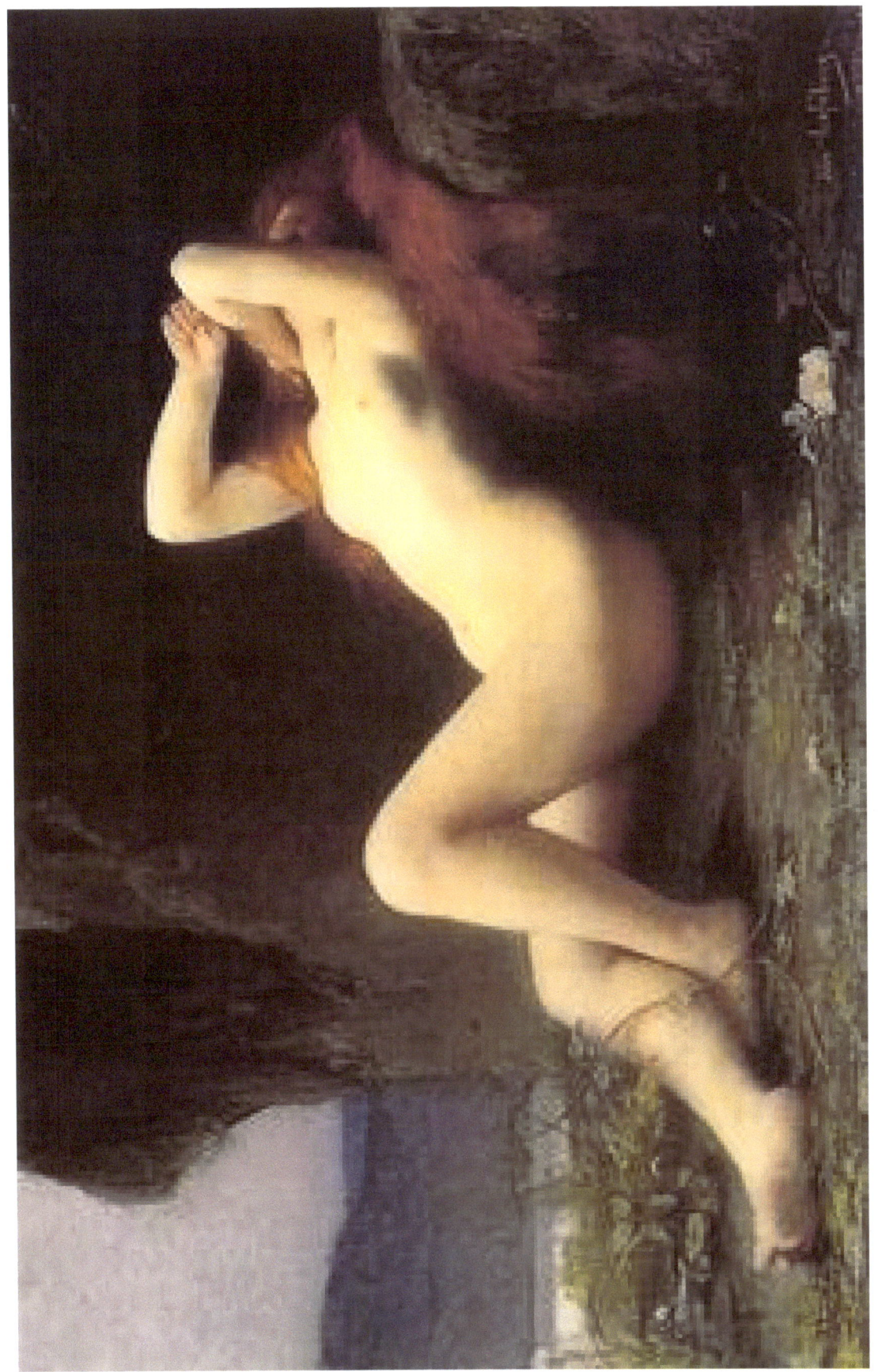

Classic, painter unknown

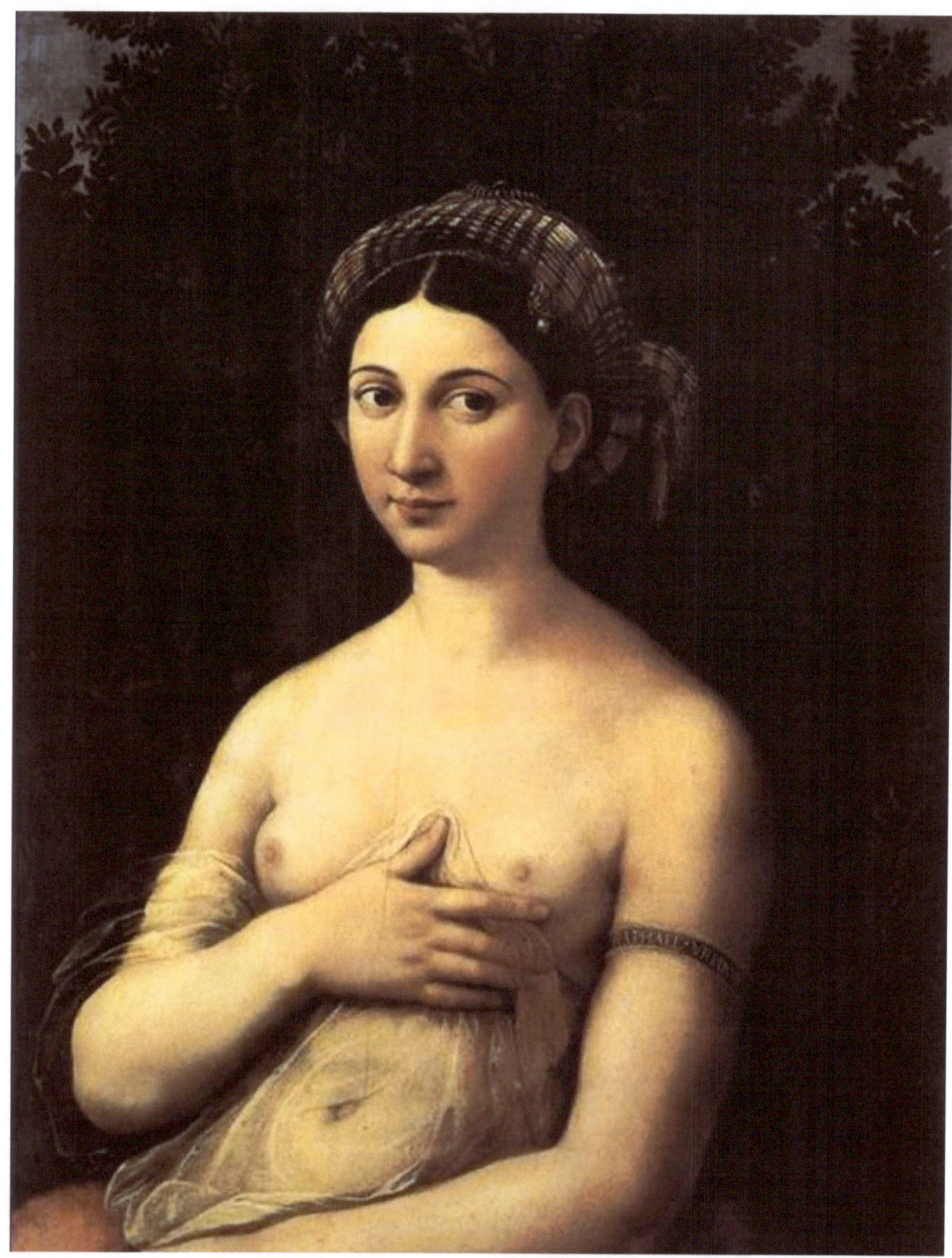
Nude Forniarina, 1518, by Raphael

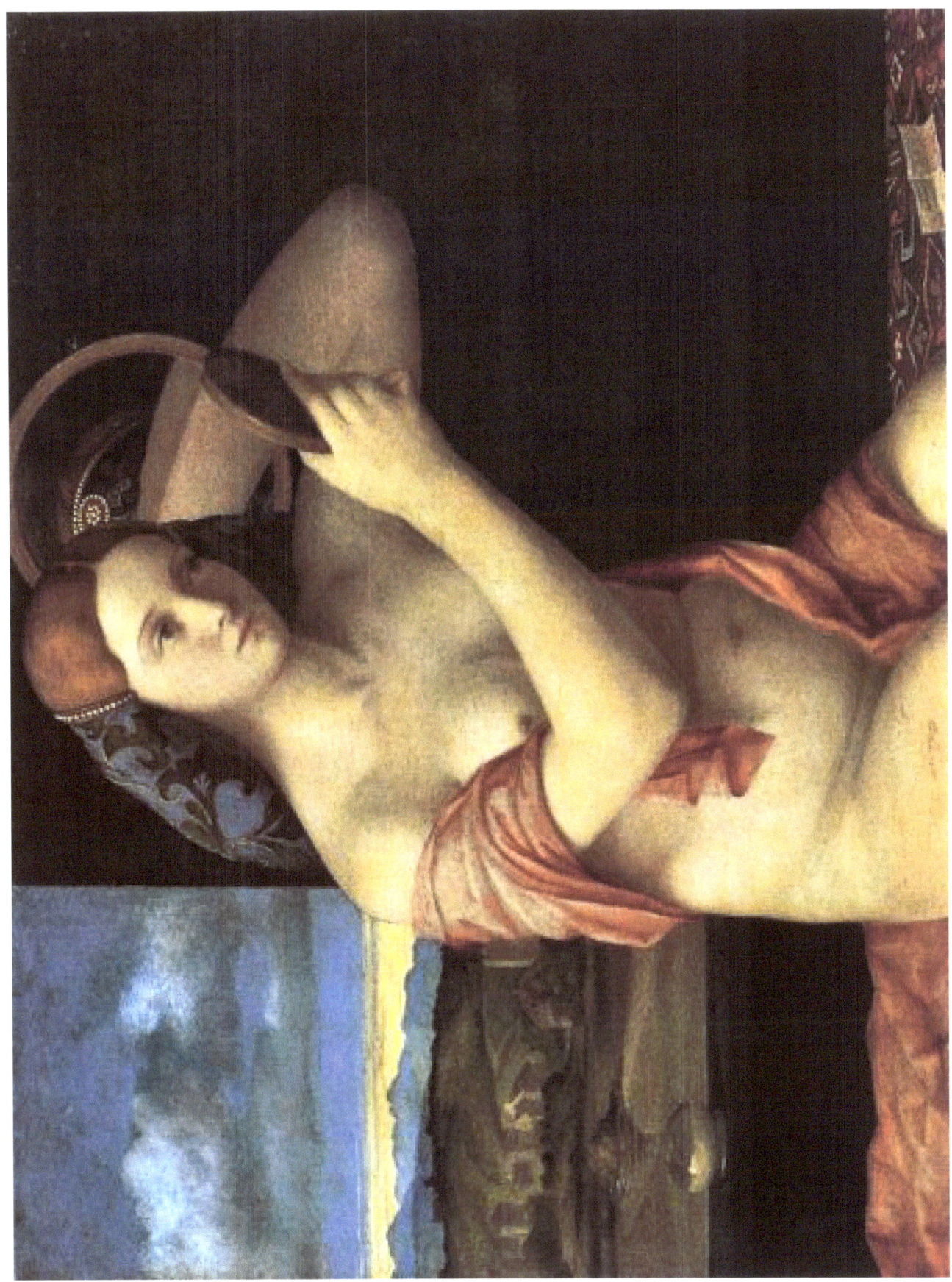

Giovanni Bellini – Venetian woman

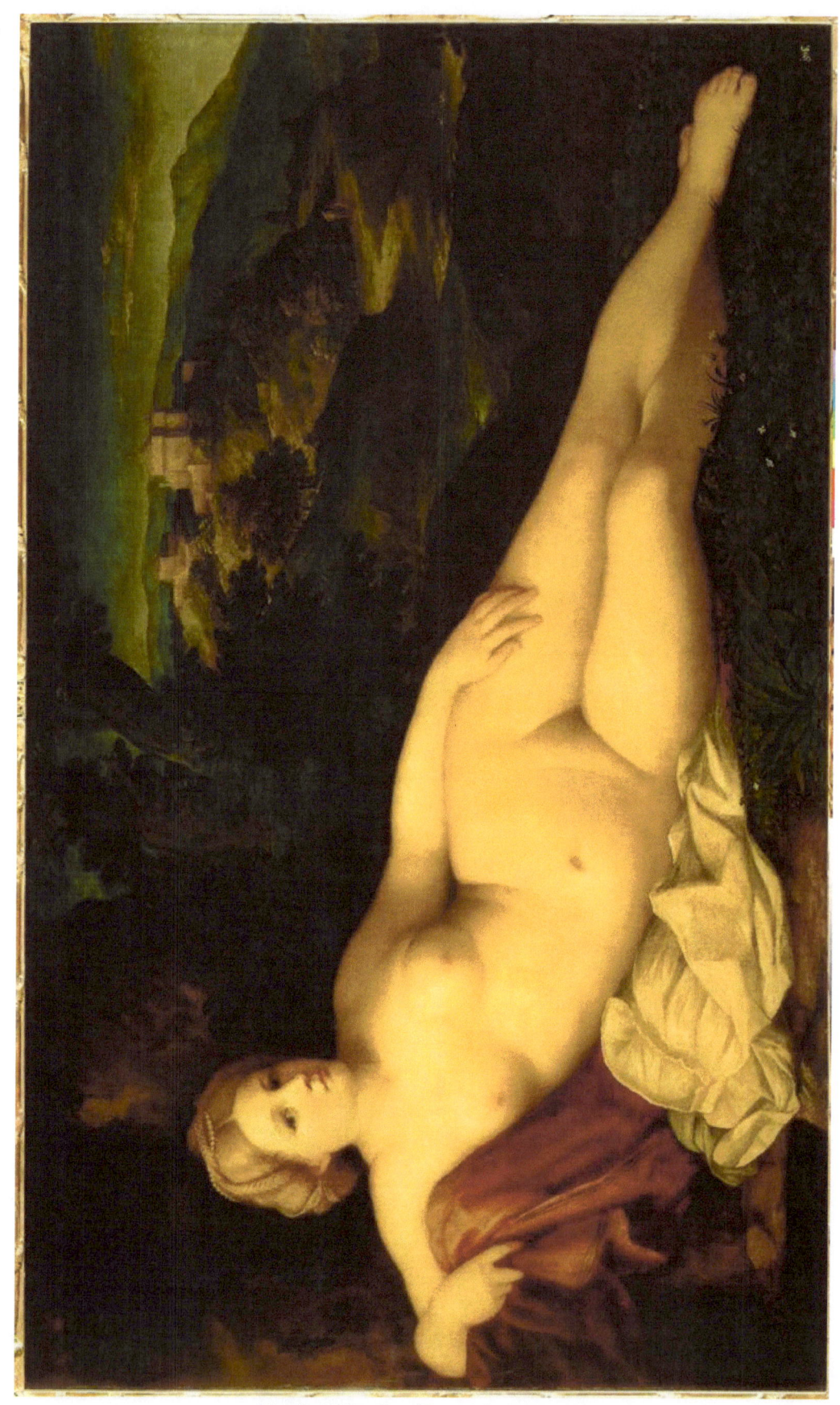

Nude Study, Renaissance

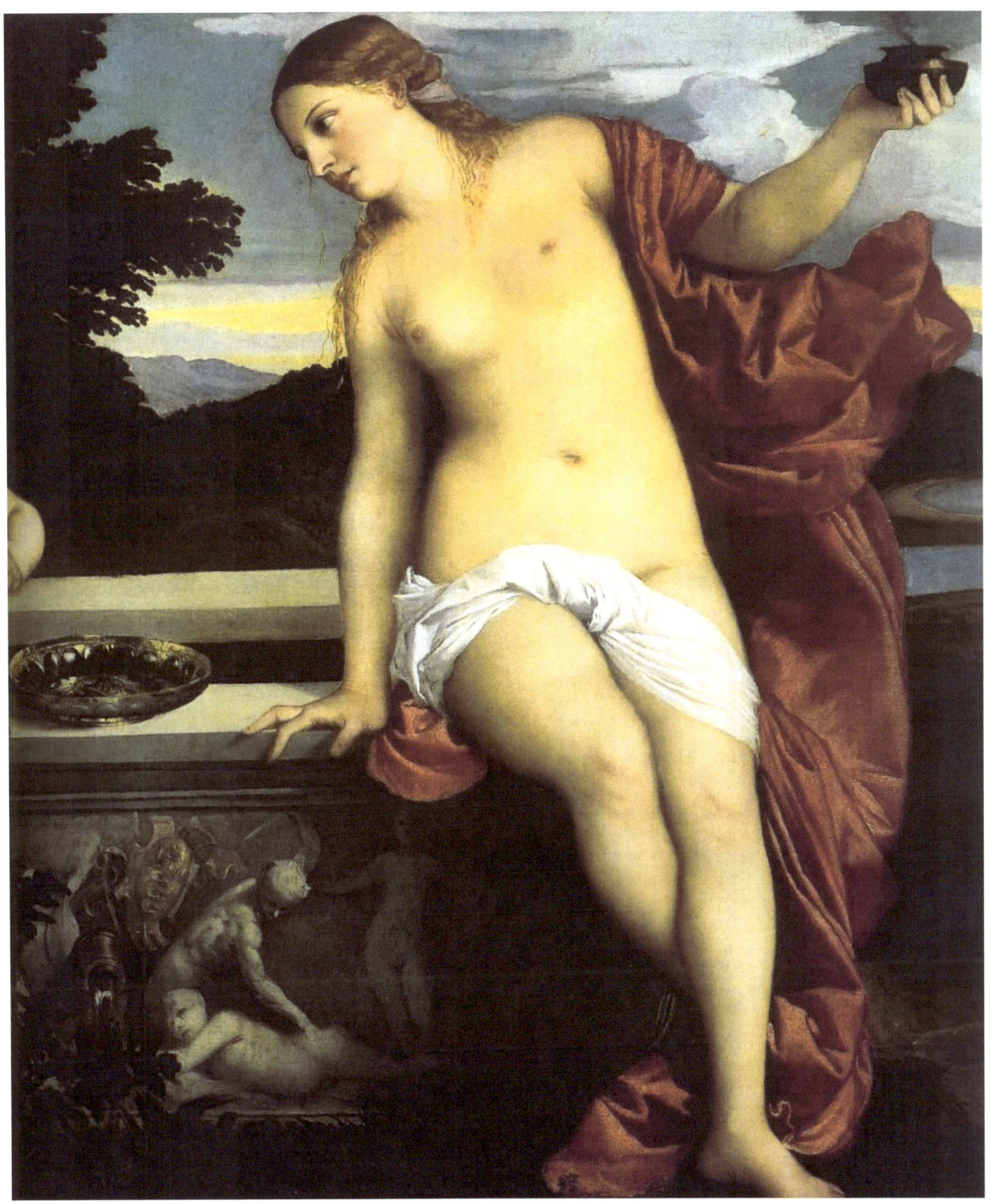

Nude Study, Renaissance

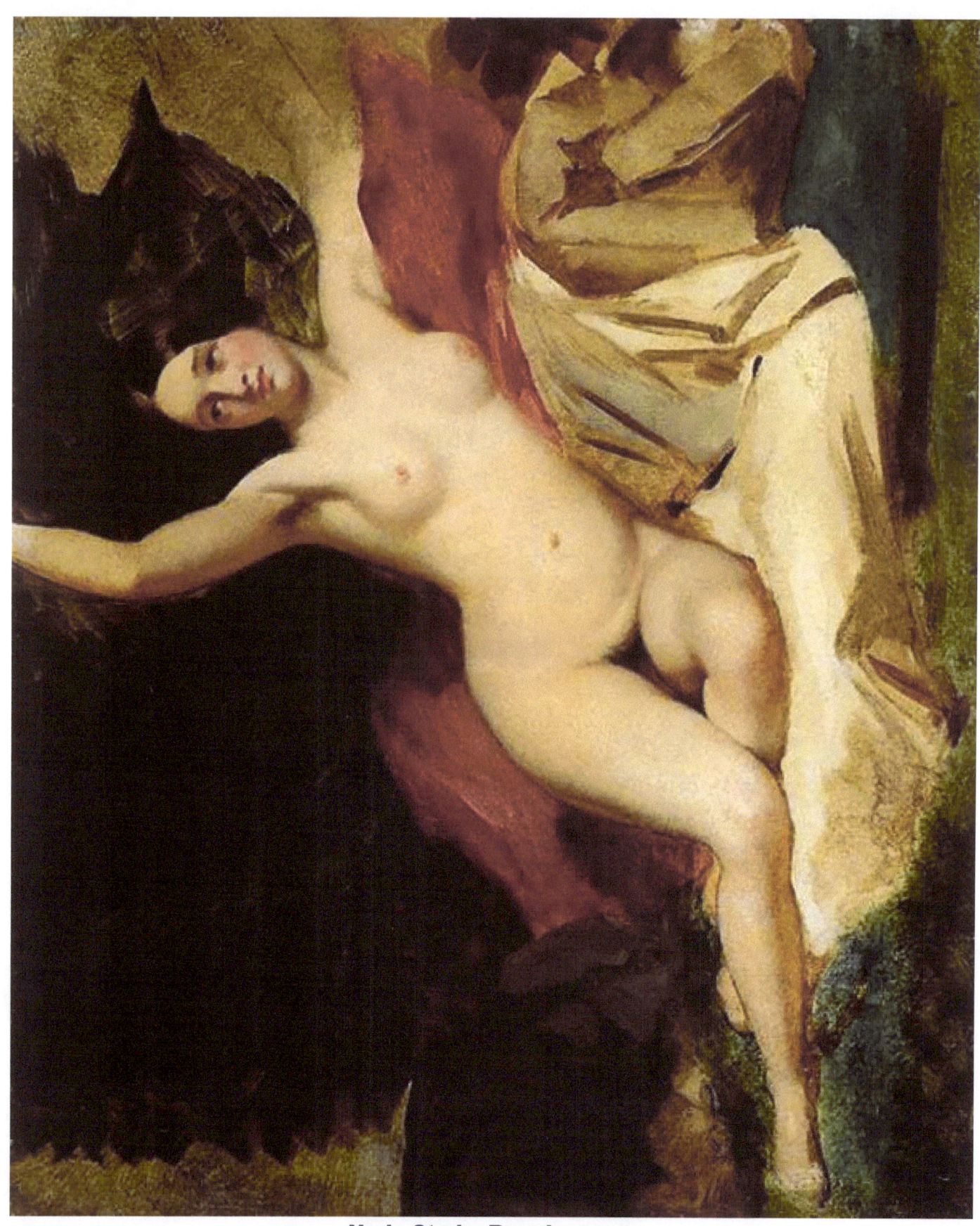

Nude Study, Renaissance

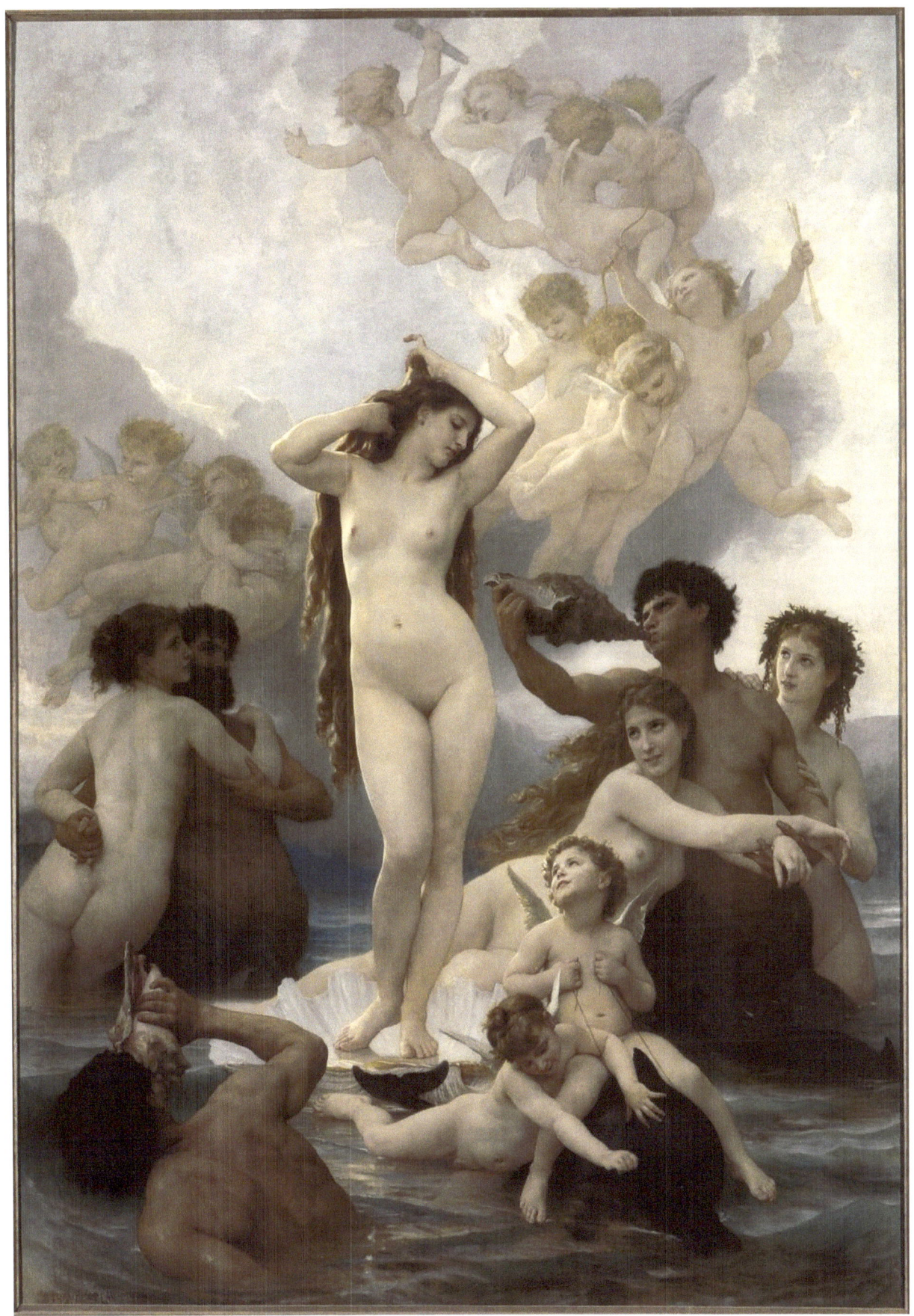

Botecelli

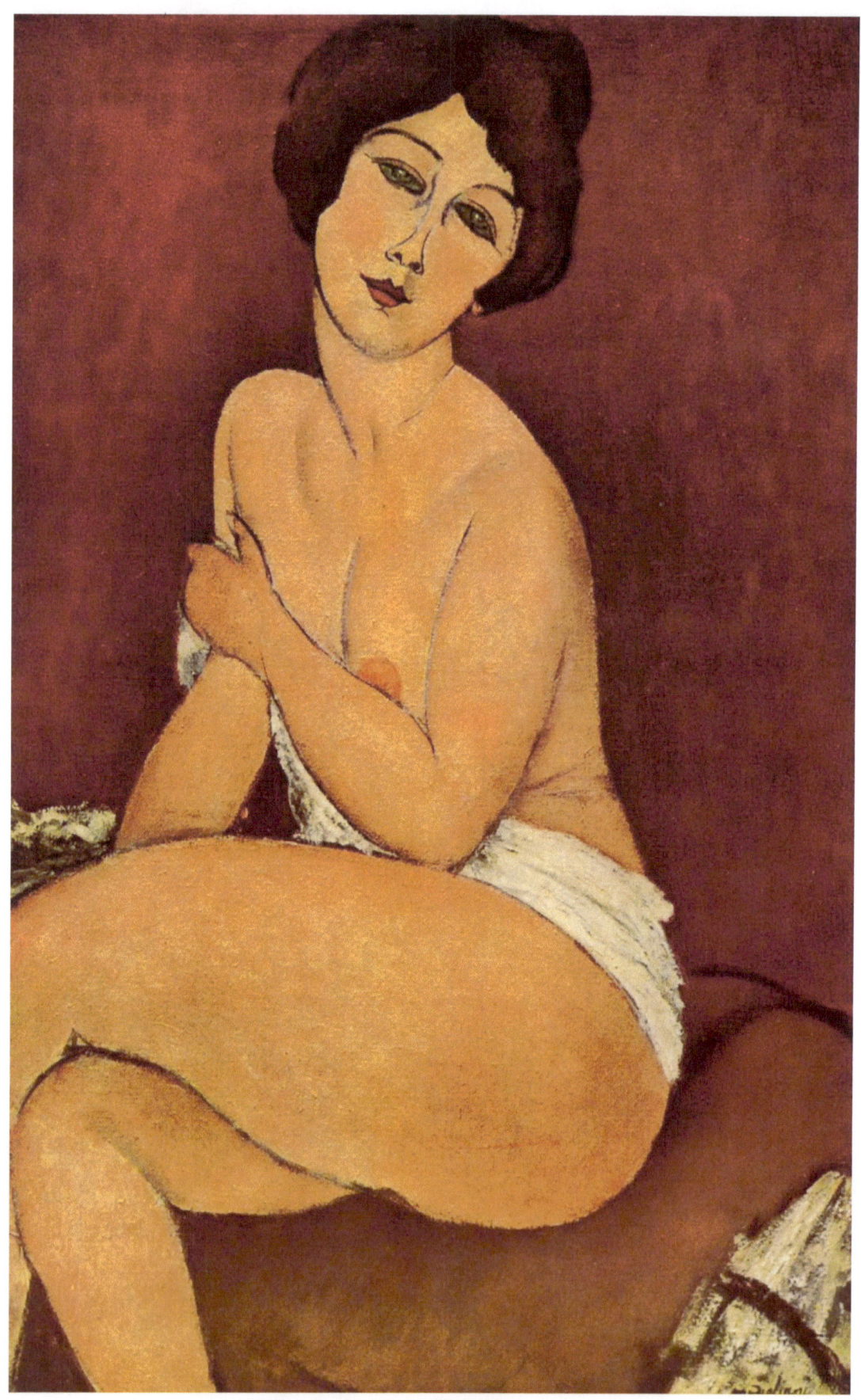

Impressionist, Renaisssance

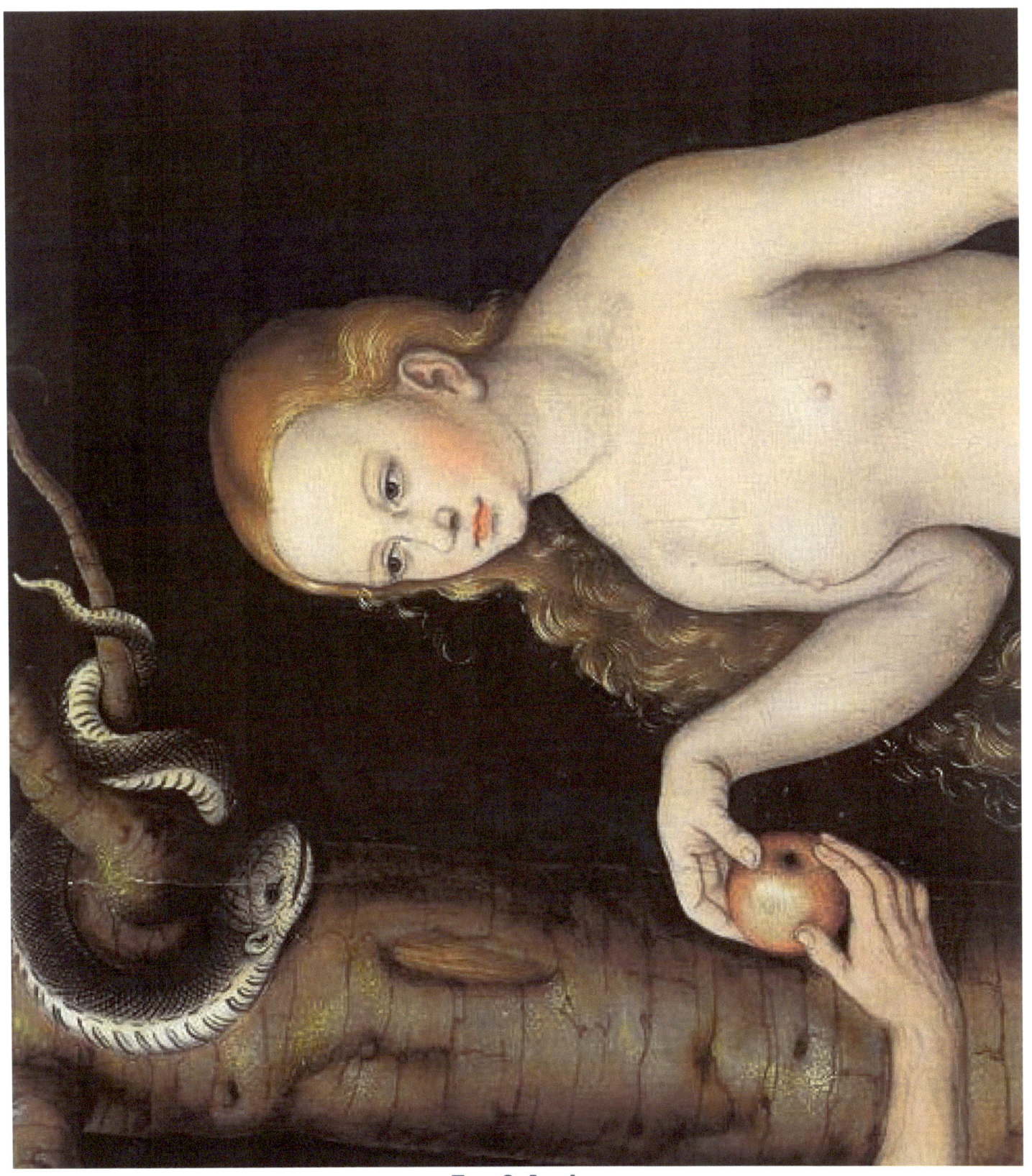

Eve & Apple

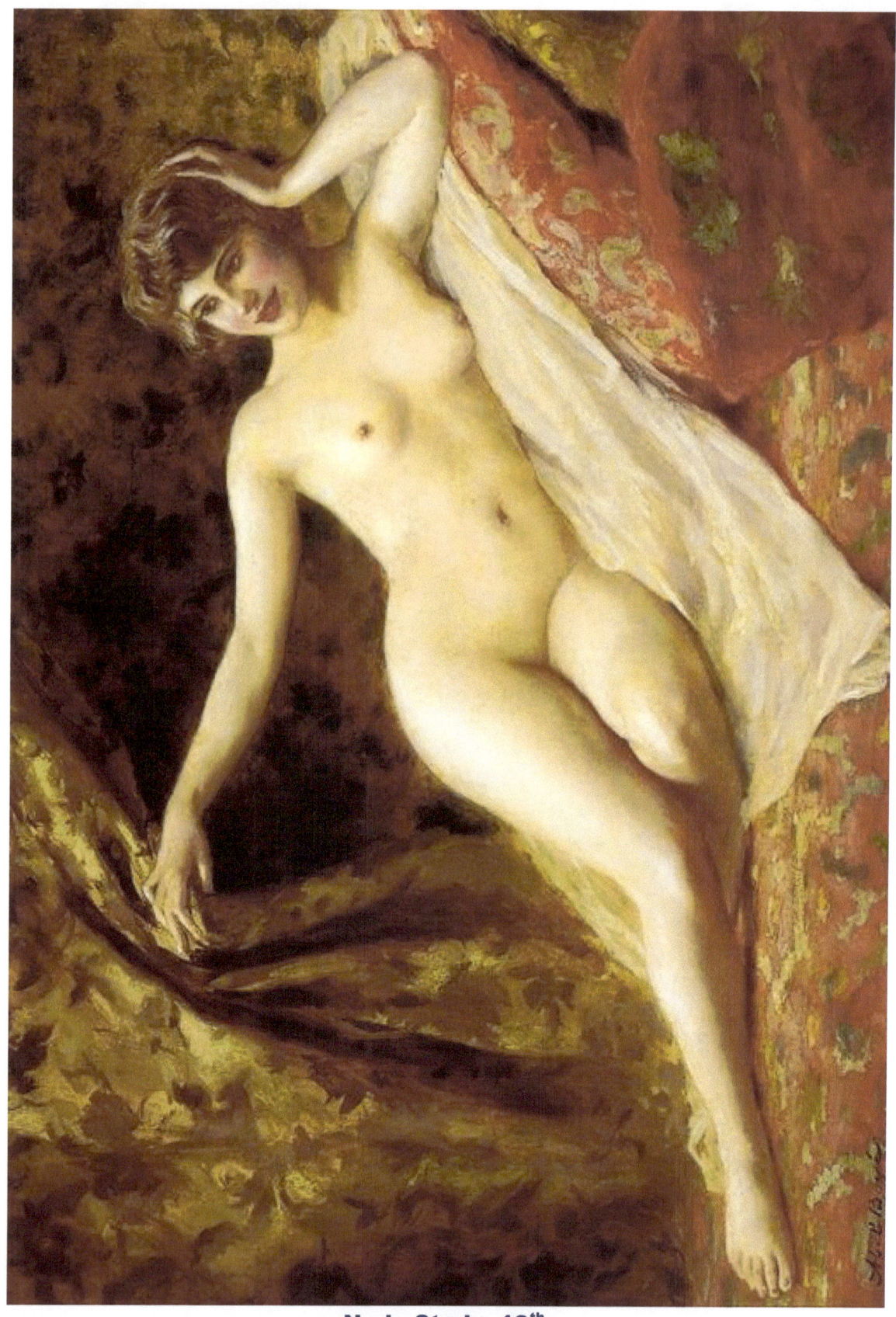

Nude Study, 19th

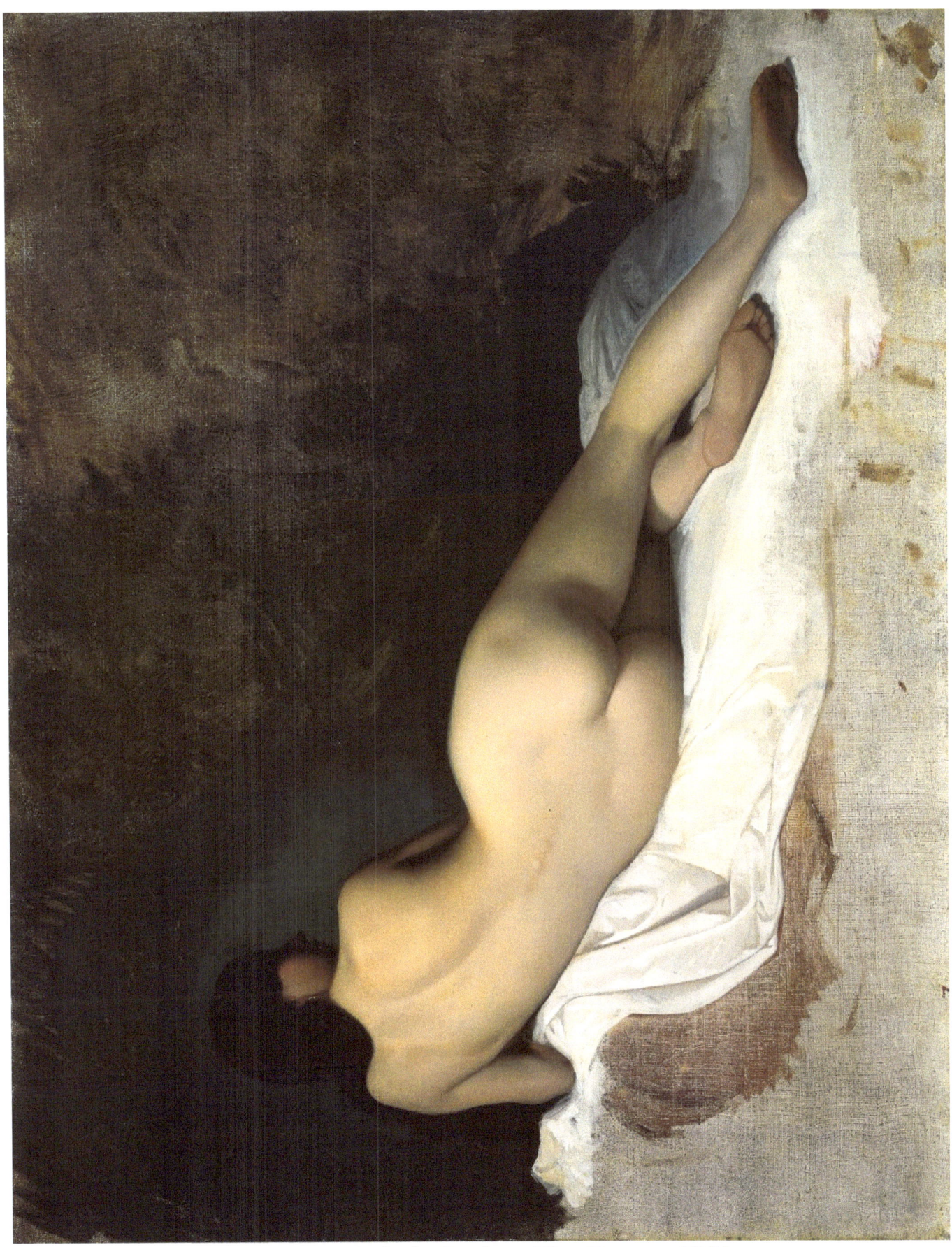
Reclining Nude by Isodoro Pils, France, 1841

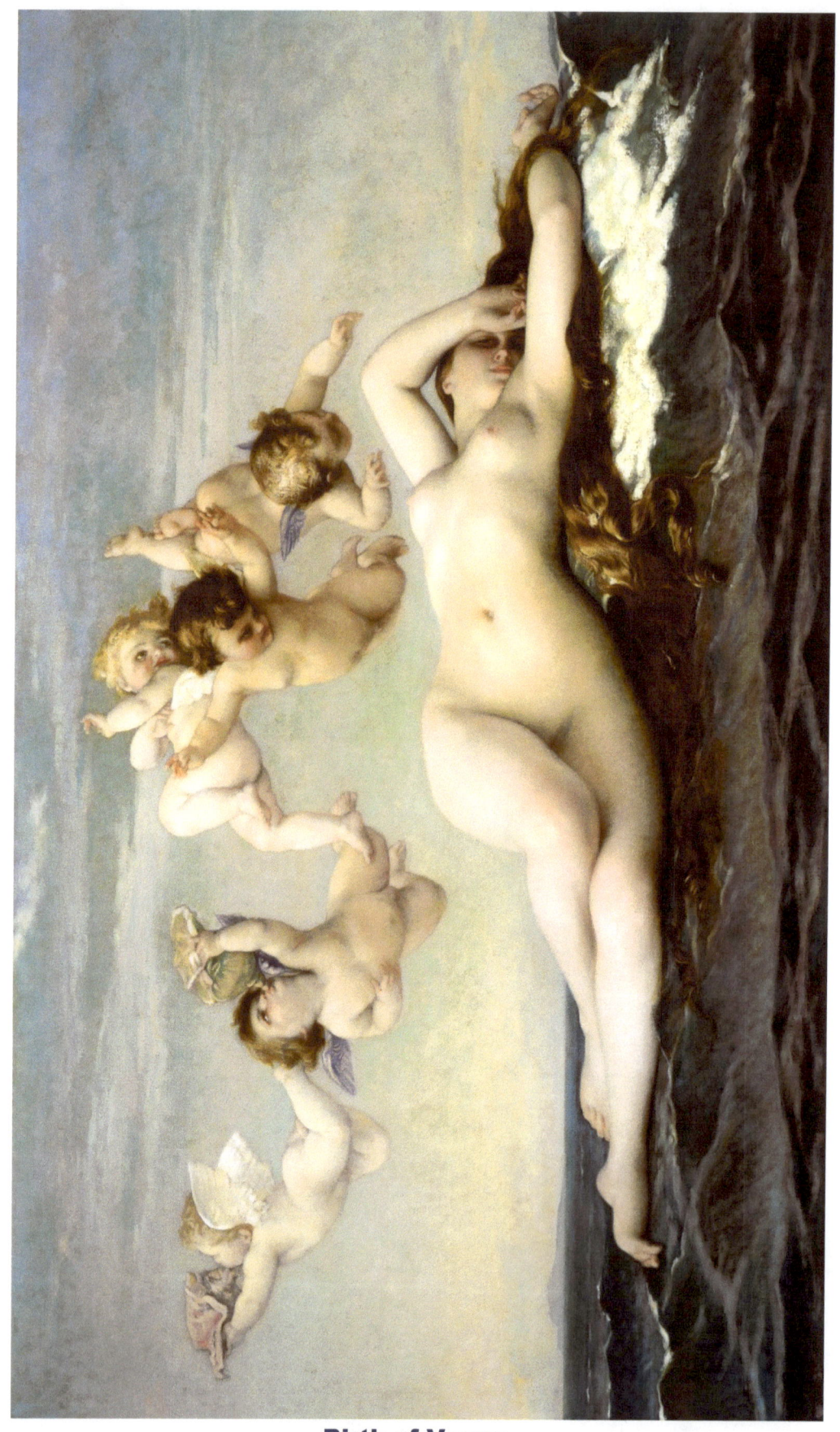

Birth of Venus

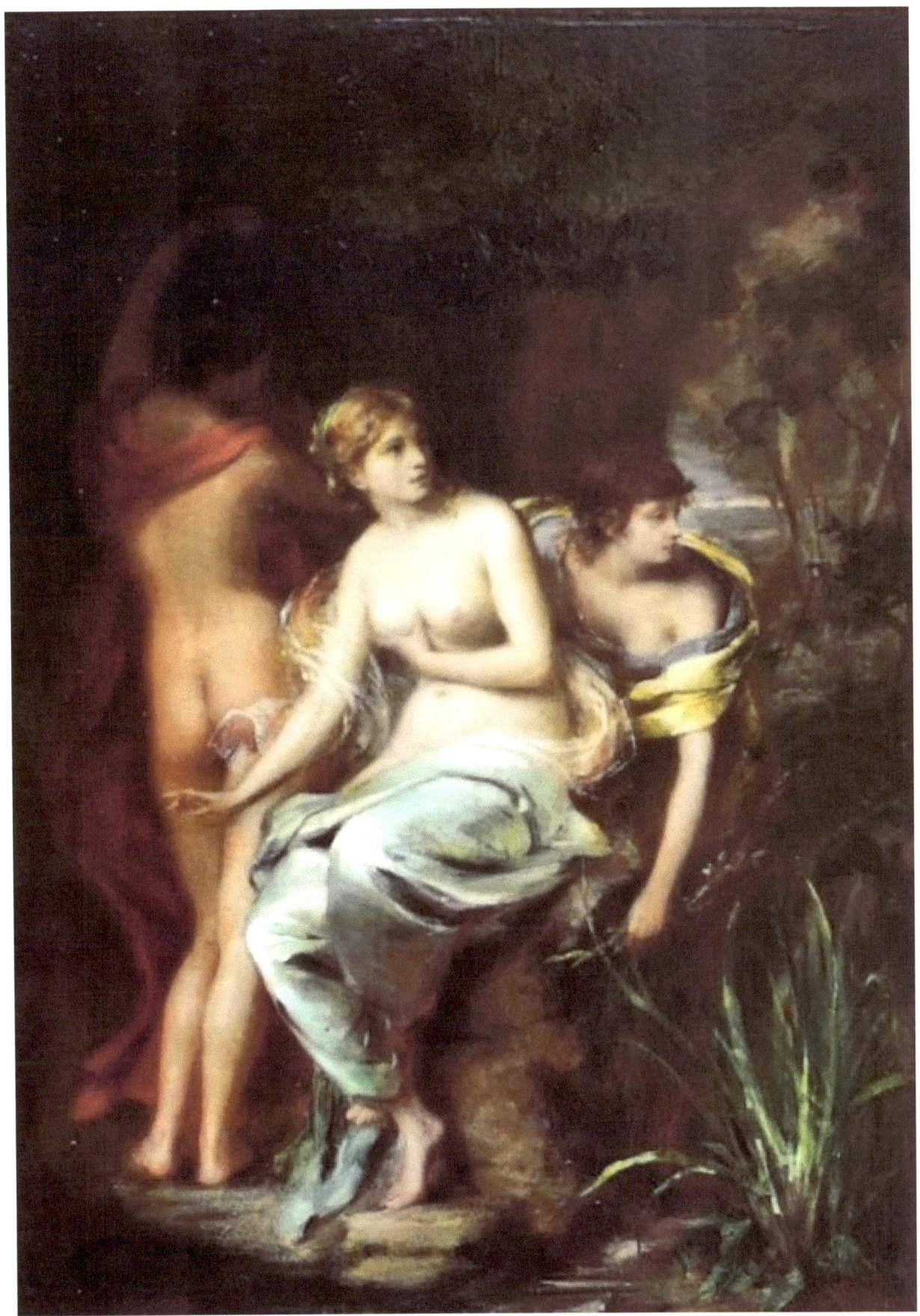
Symbolic Portrait by Charles Messara, 19th

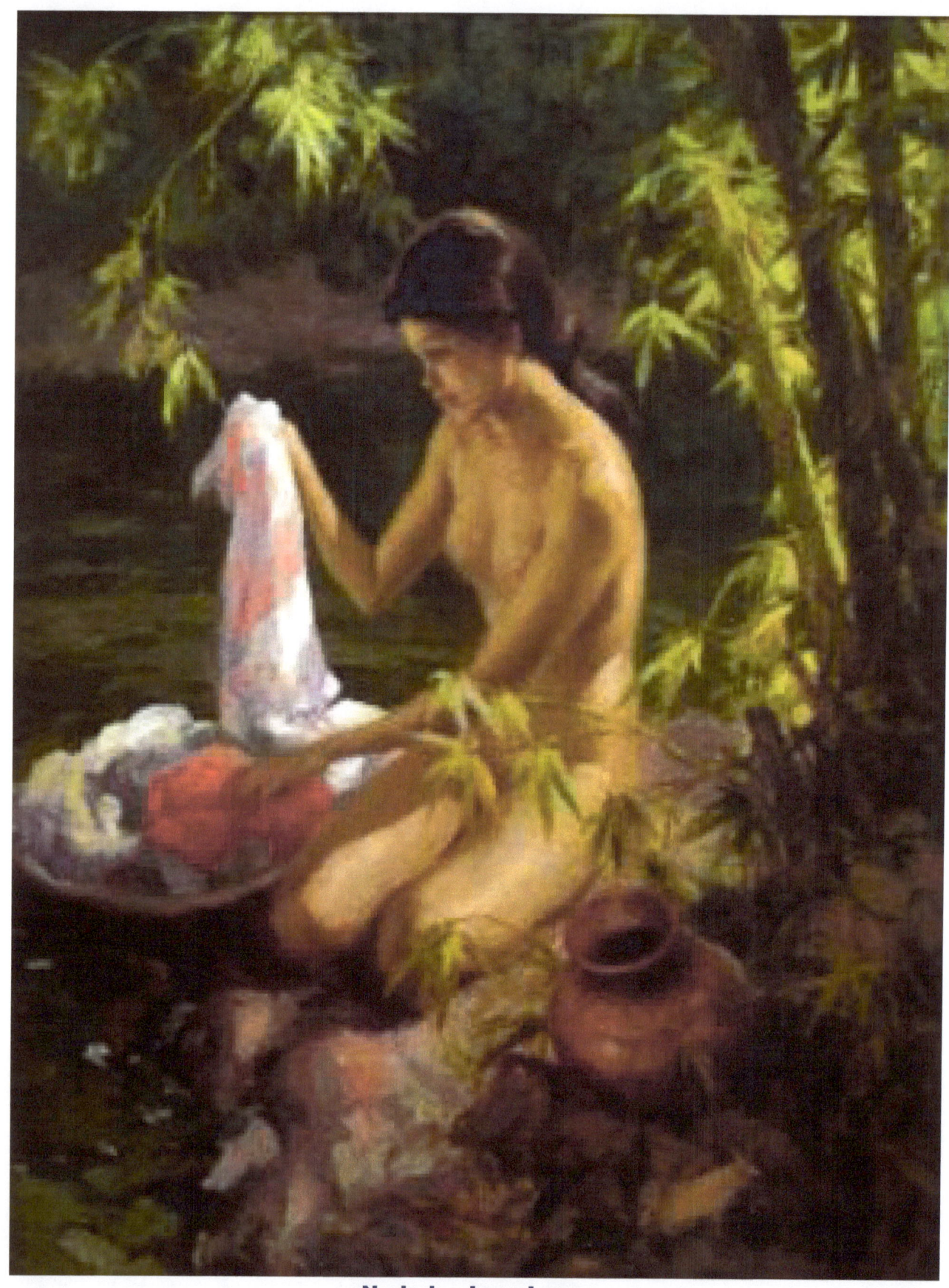

Nude by Juan Luna

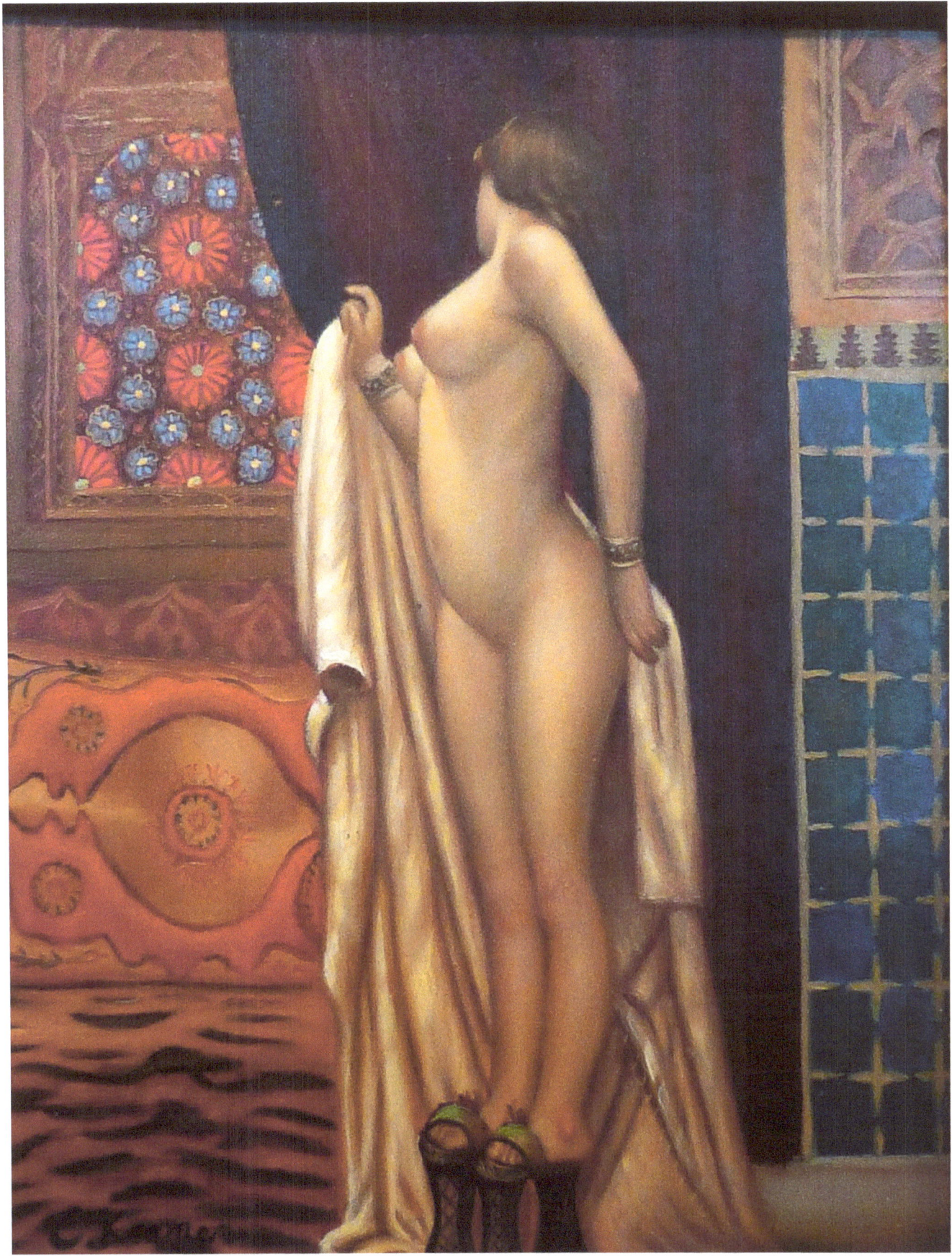
By Edgar L. Owen, 19th

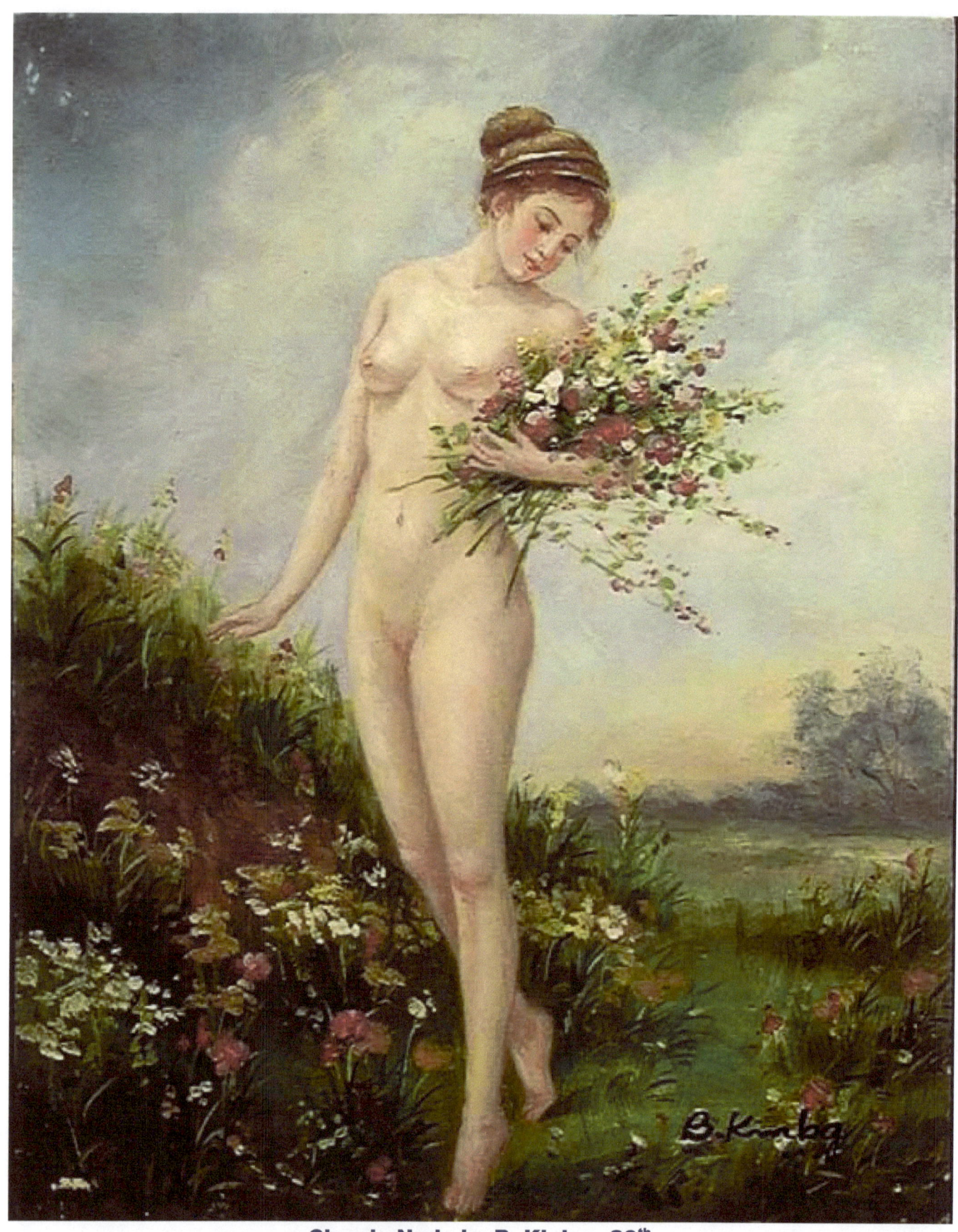

Classic Nude by B. Kinlog, 20th

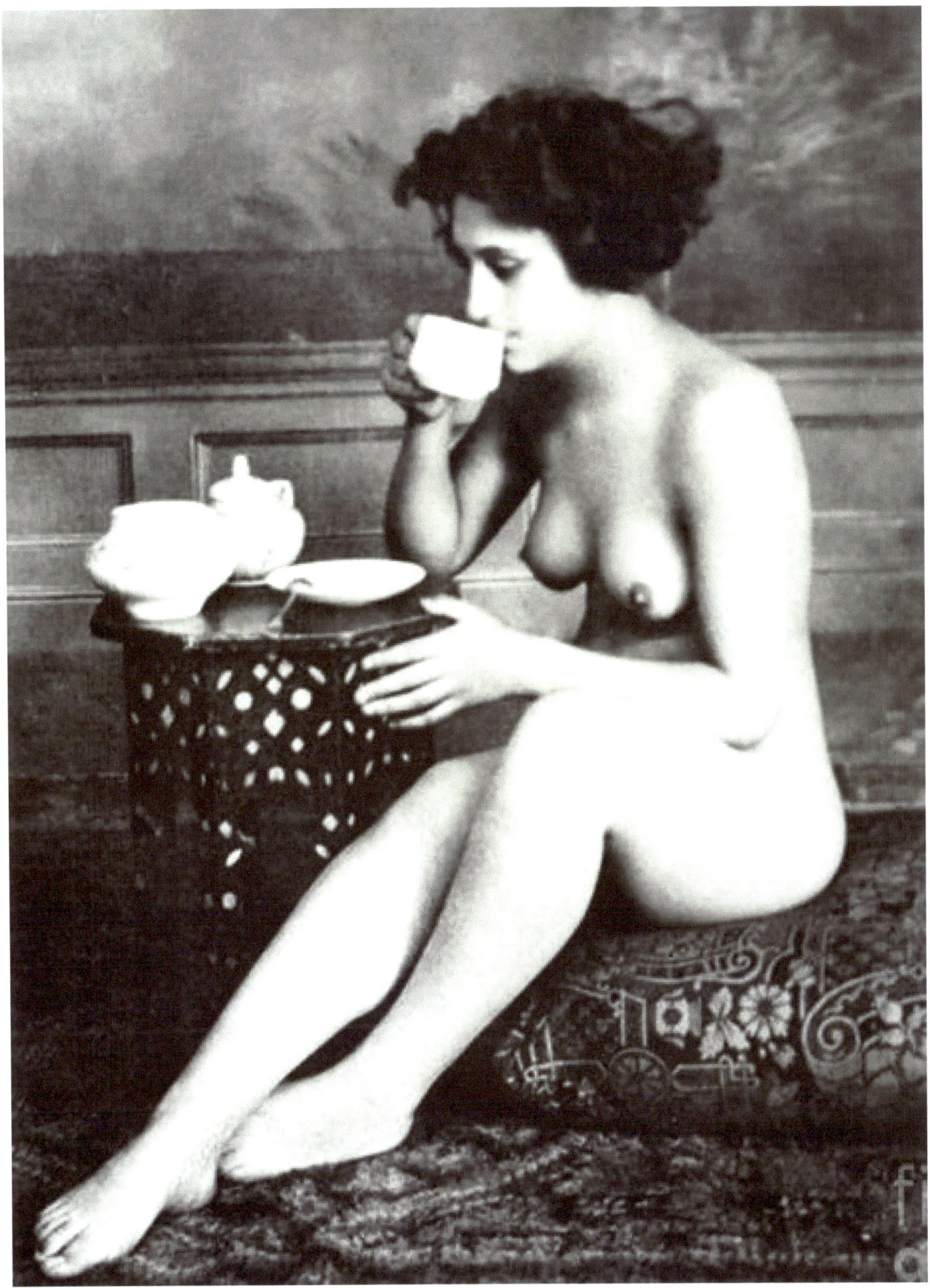
Drinking tea by Granger, 19th, phto-fineart

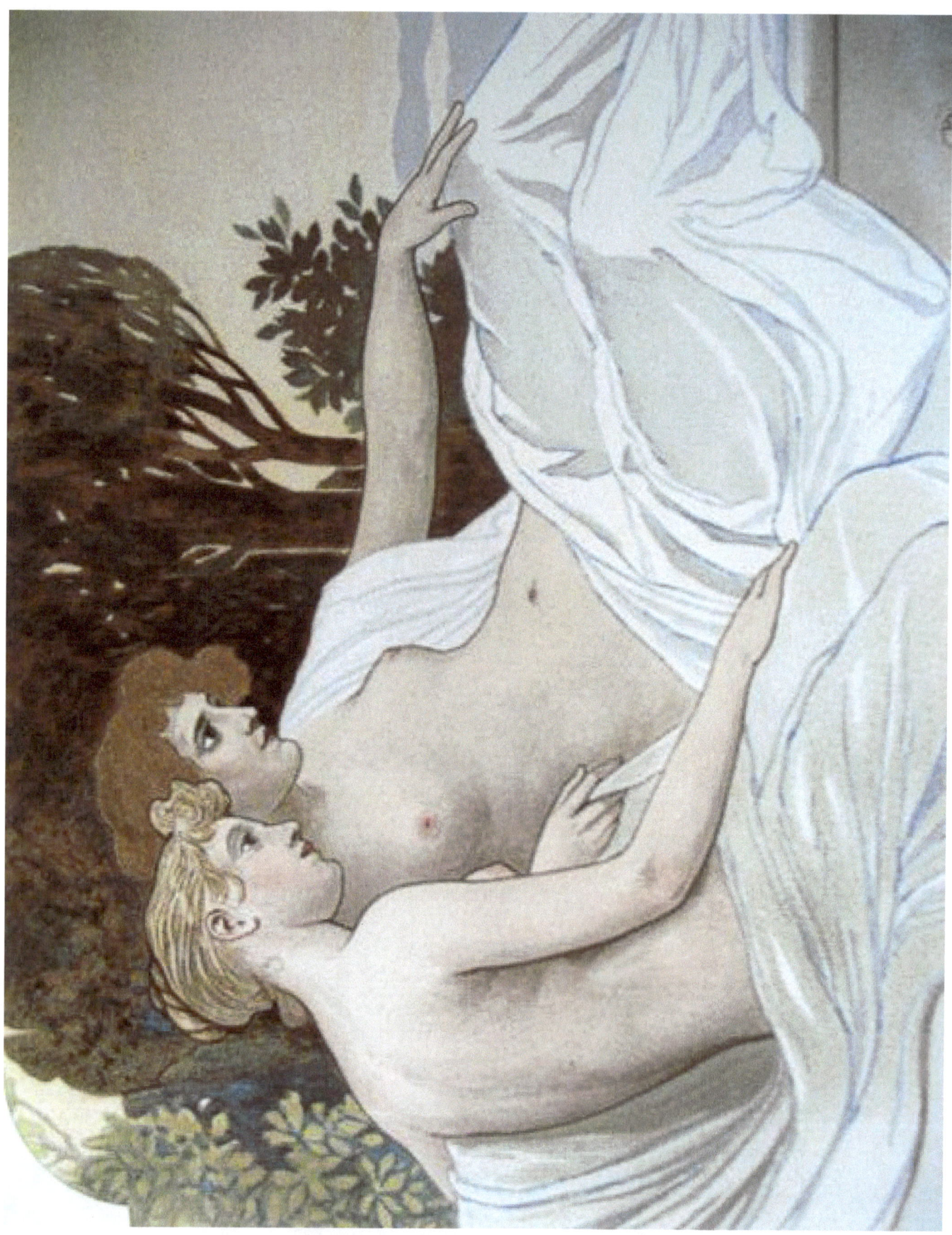

Ladies, by Russler, Austria, 19ᵗʰ

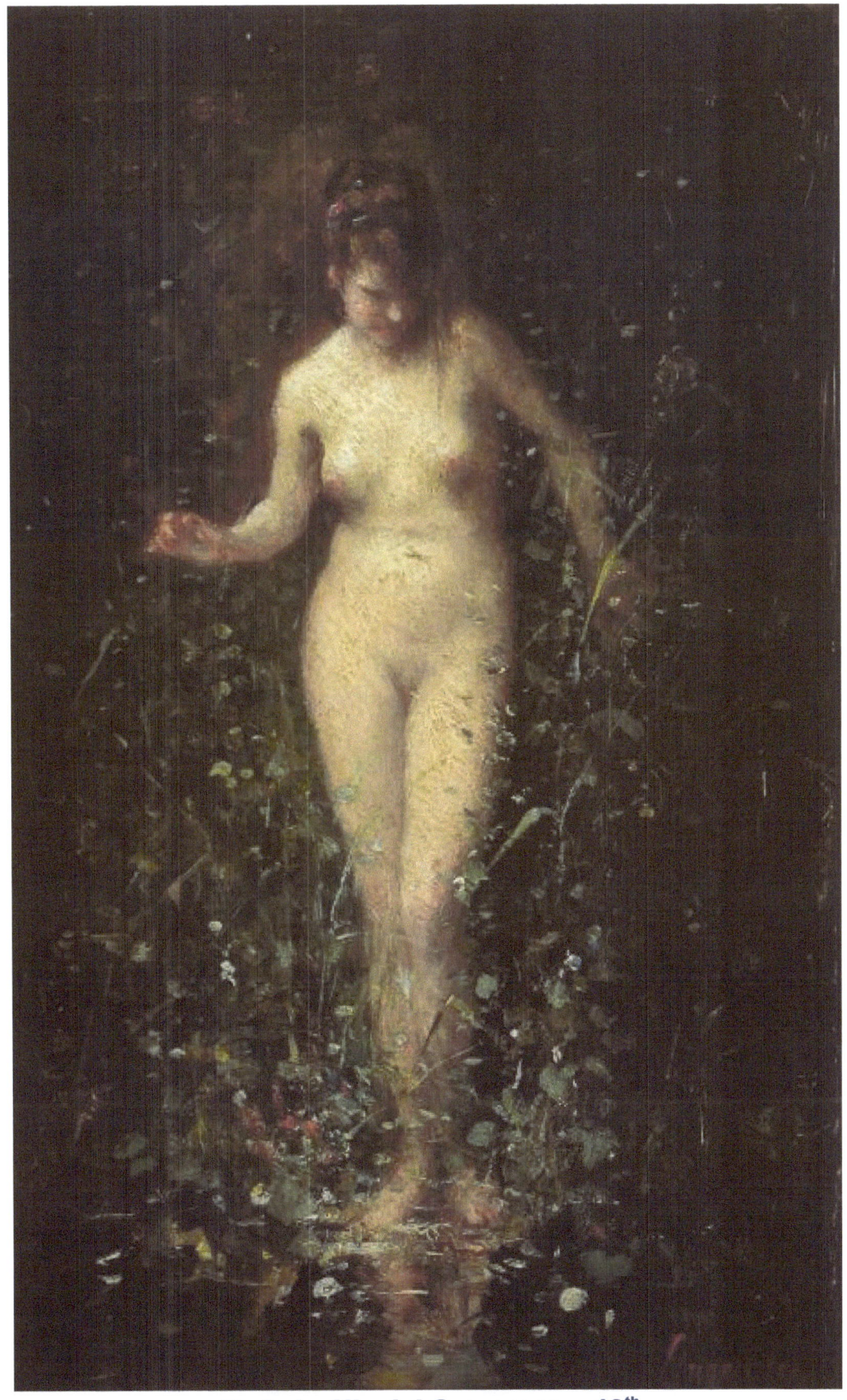

Nude by Nicolai Gregorescu, 19th

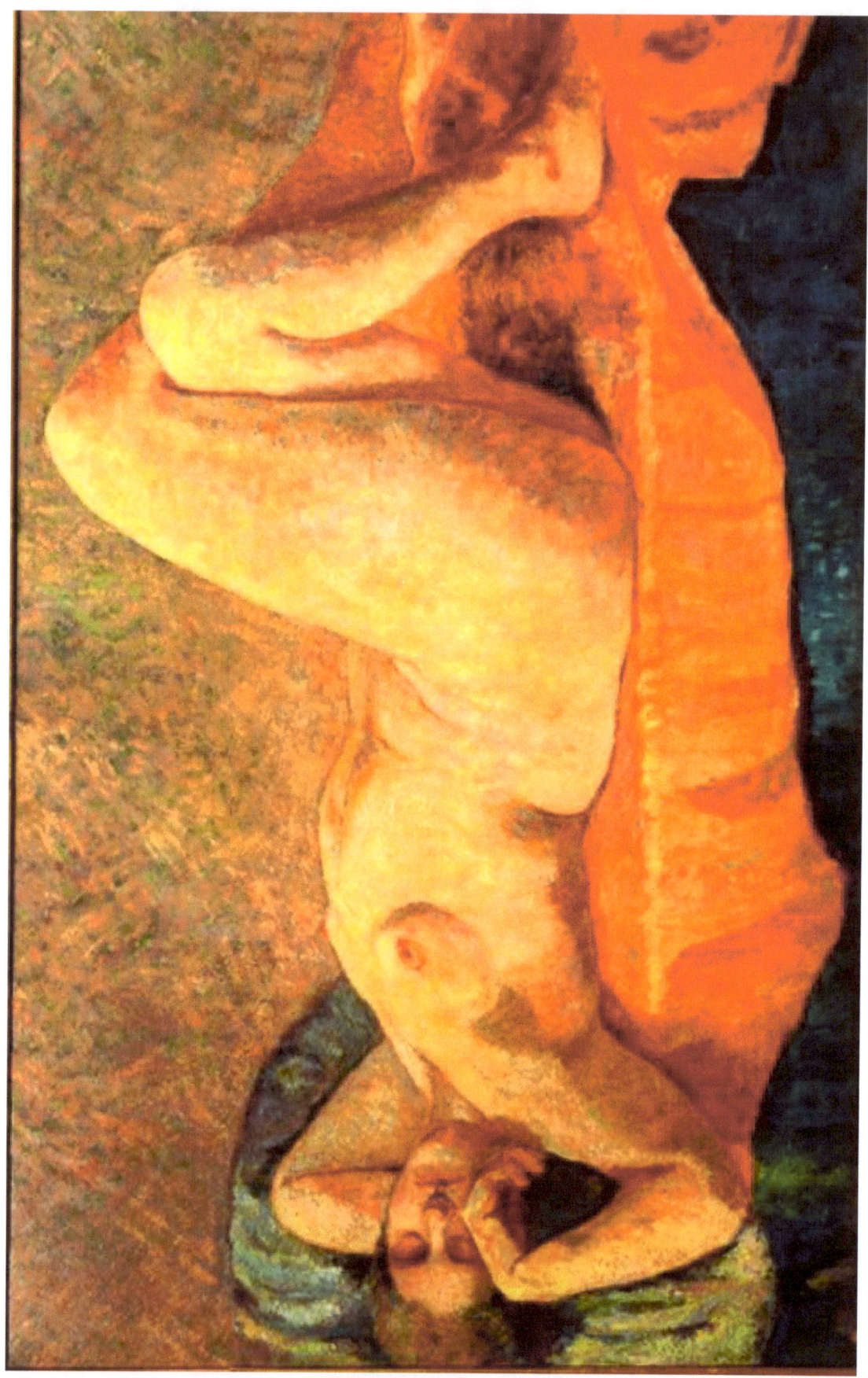

Impressinist, 19th

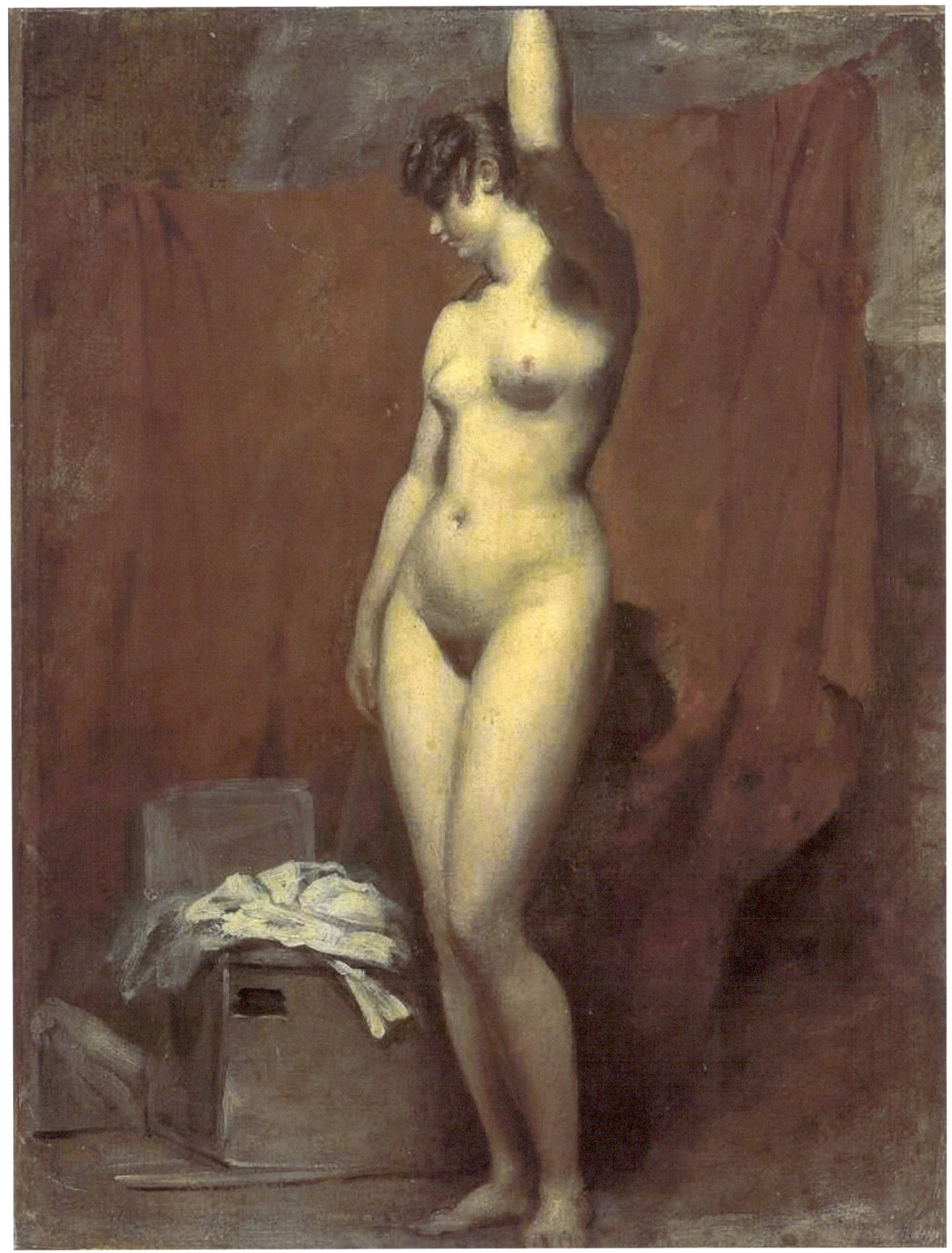
Nude by William Etty, 1787-1847

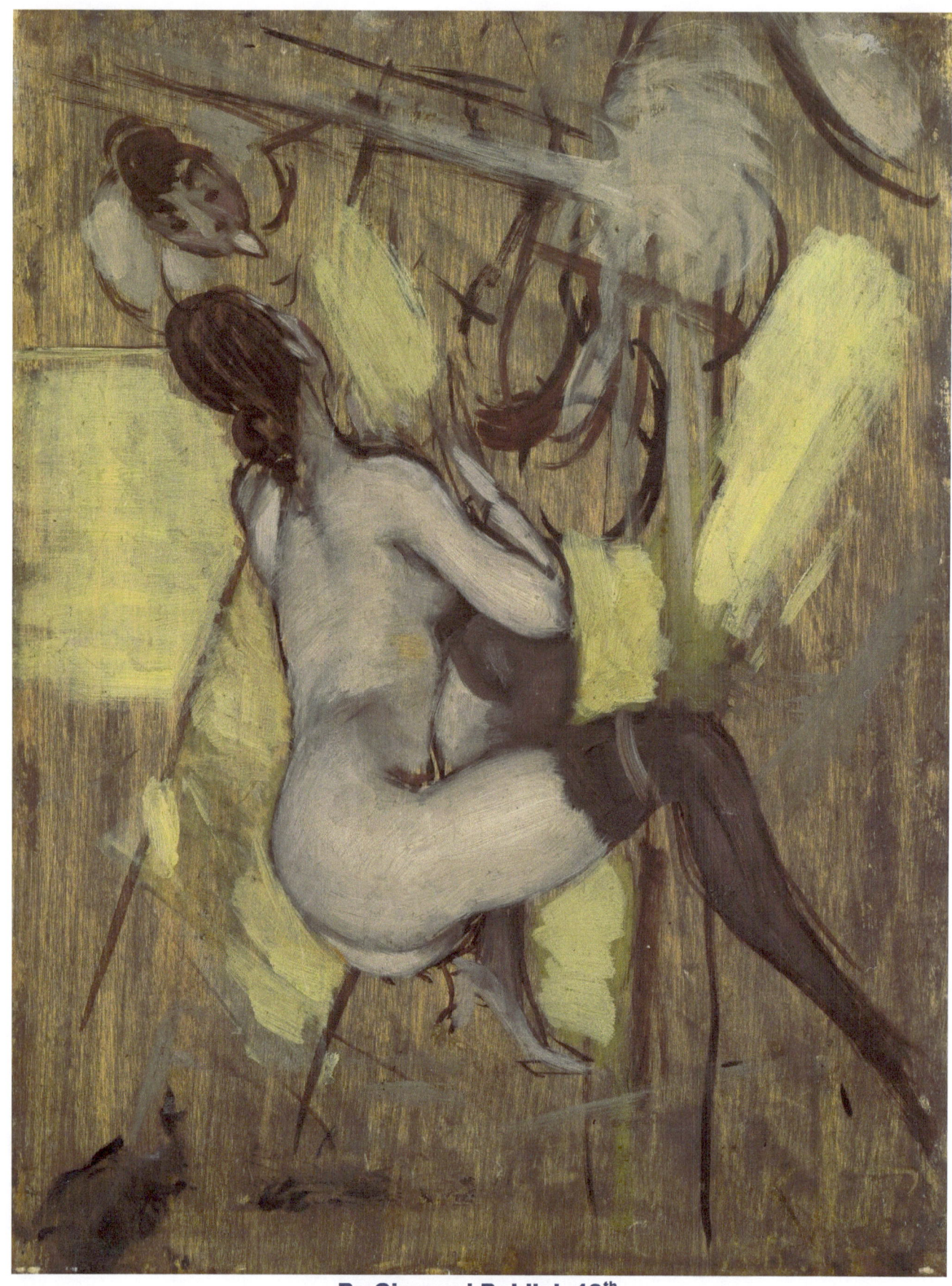

By Giovanni Boldini, 19th

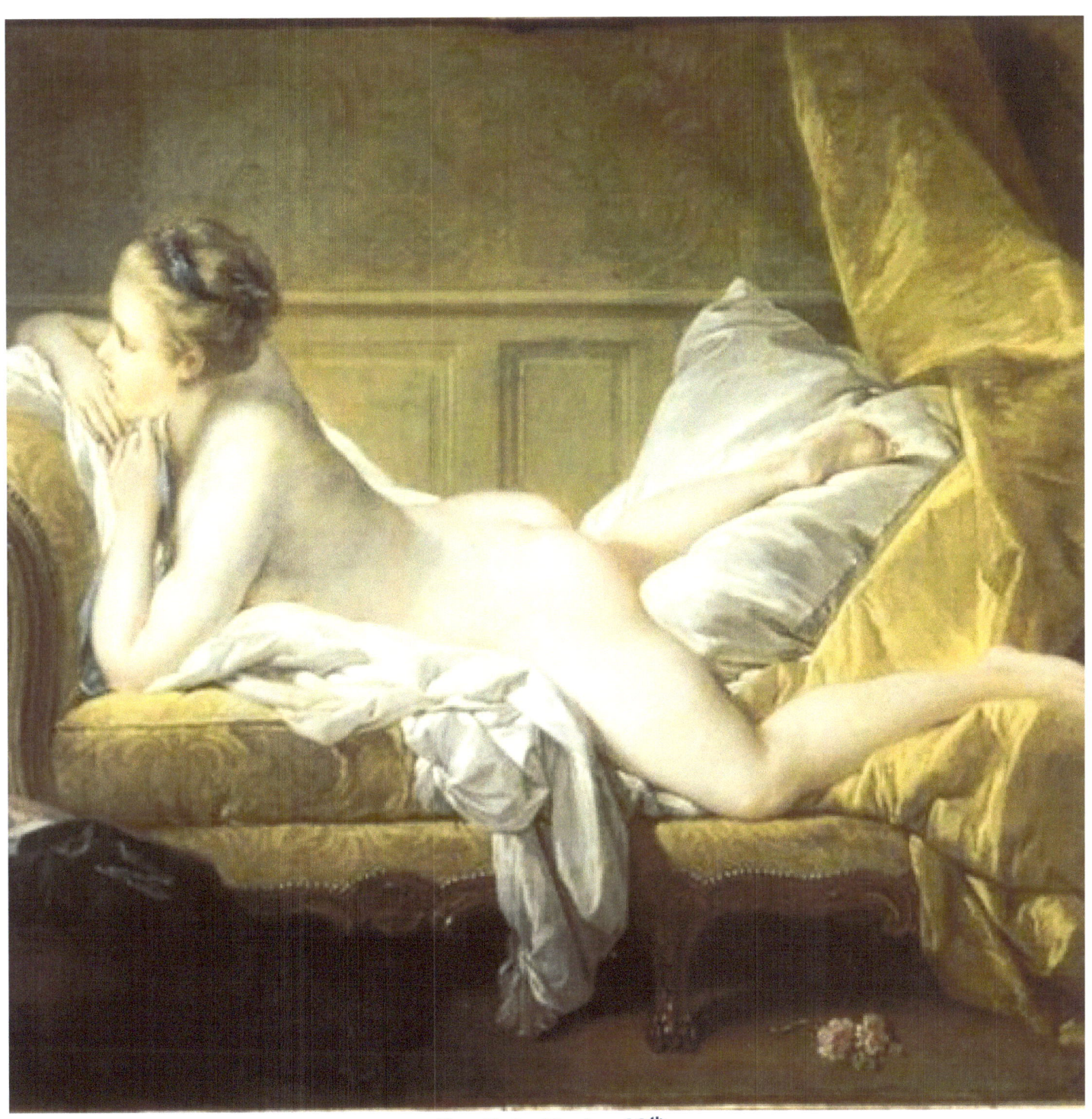

Reclinig Nude, 19th

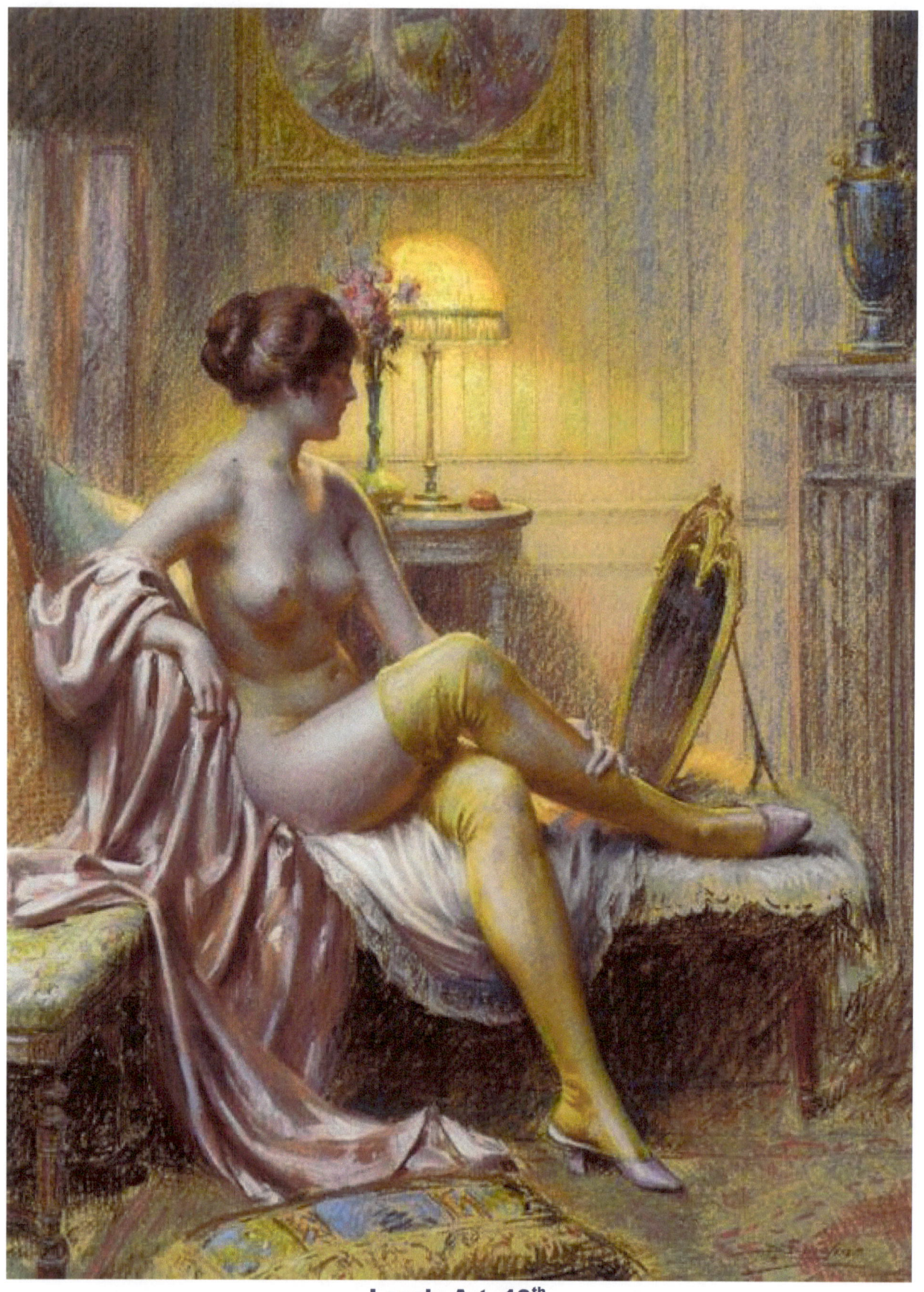

Lovely Art, 19th

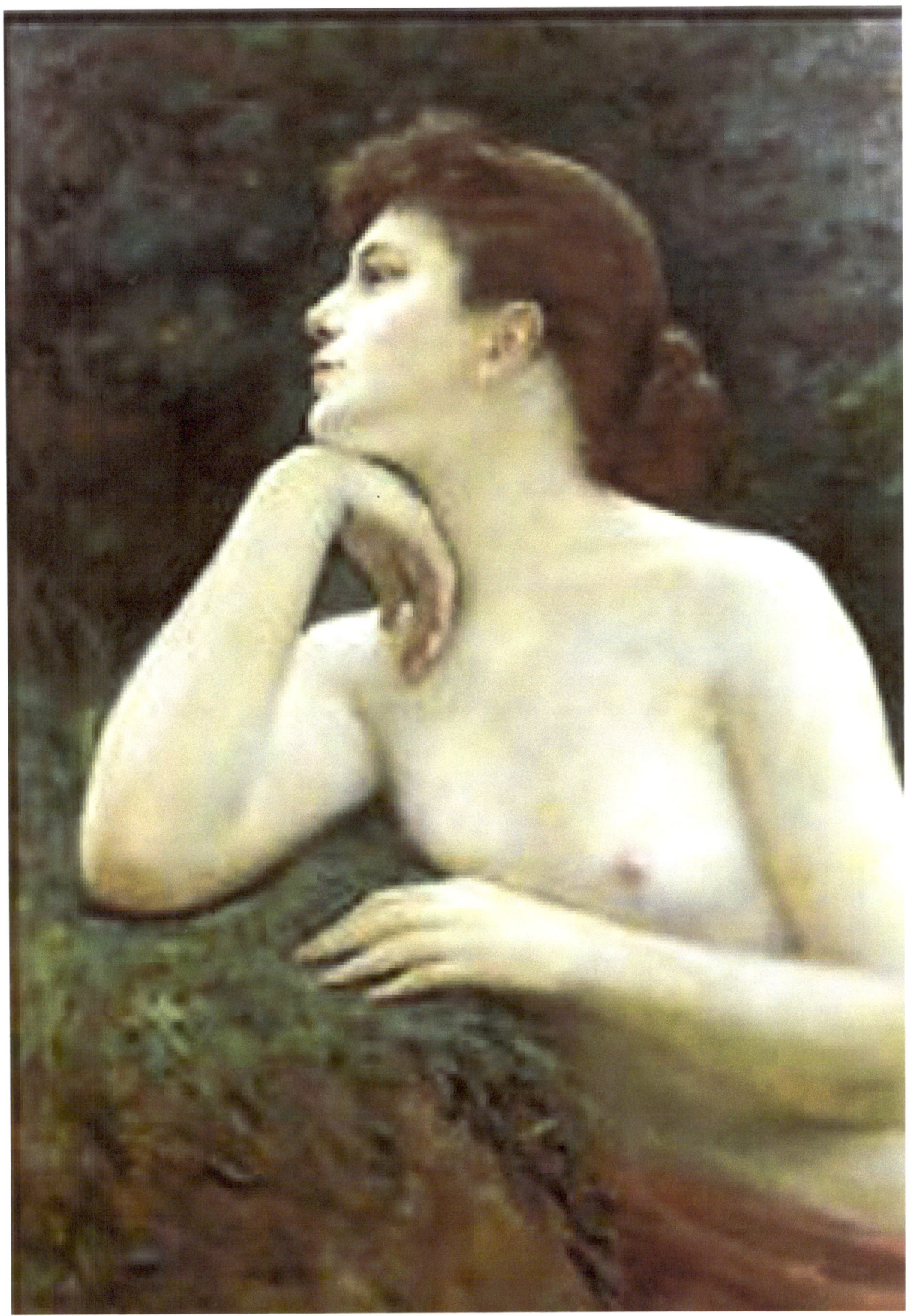

Nude Study, 19th

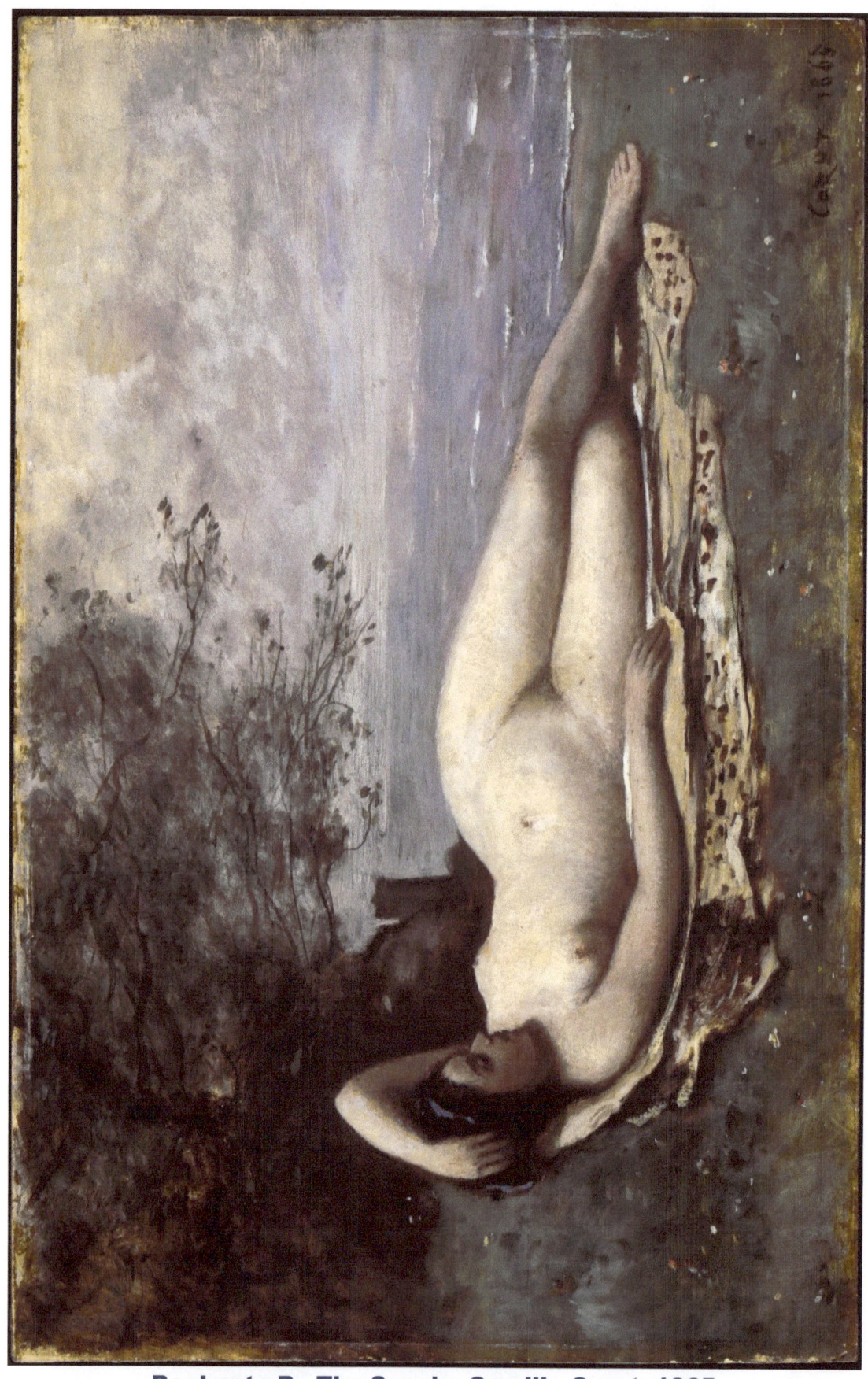
Bachante By The Sea, by Camille Corot, 1865

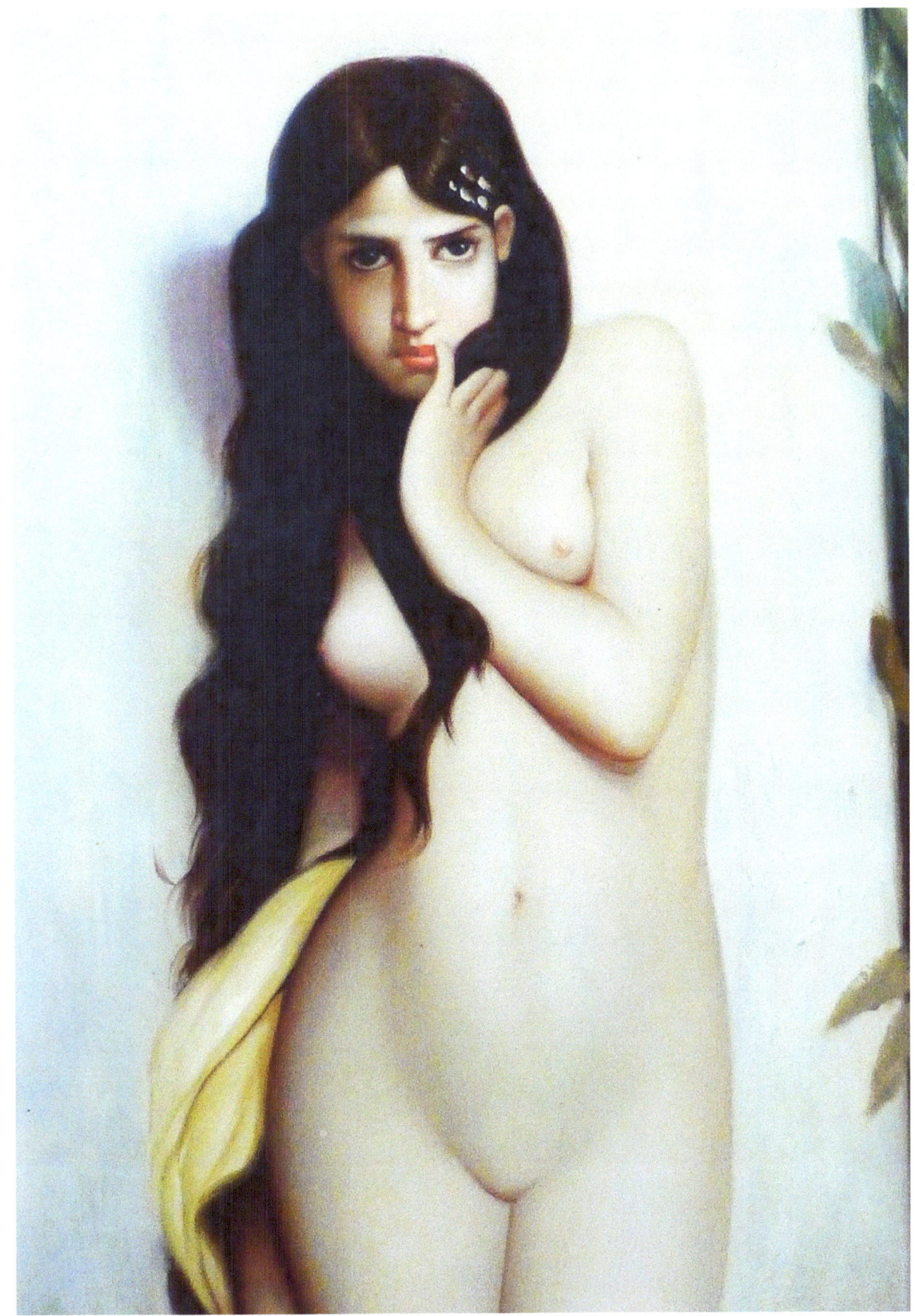

By Edgar L. Owen, 19th

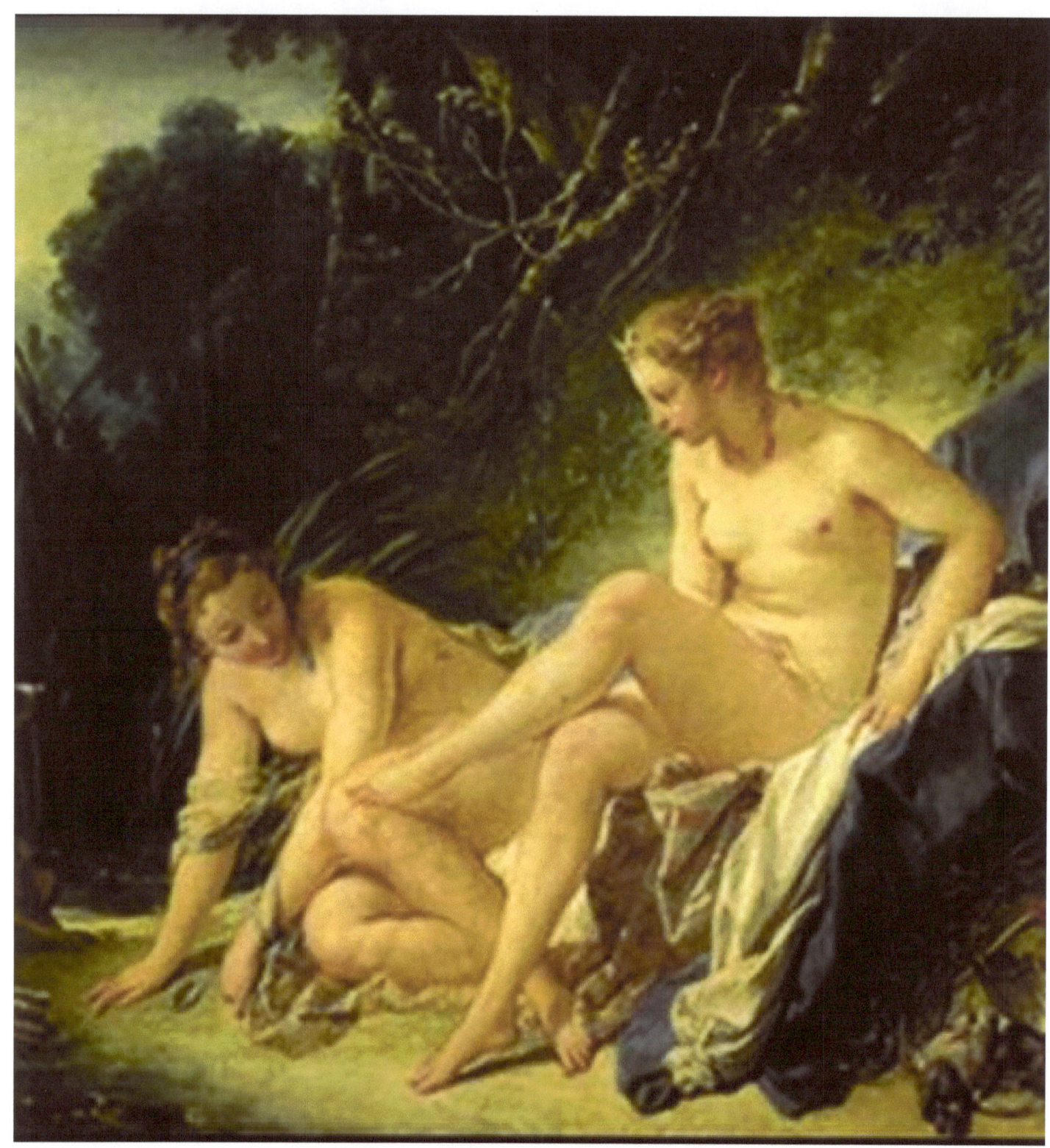
Goddess Diana by Boucher, 1700s

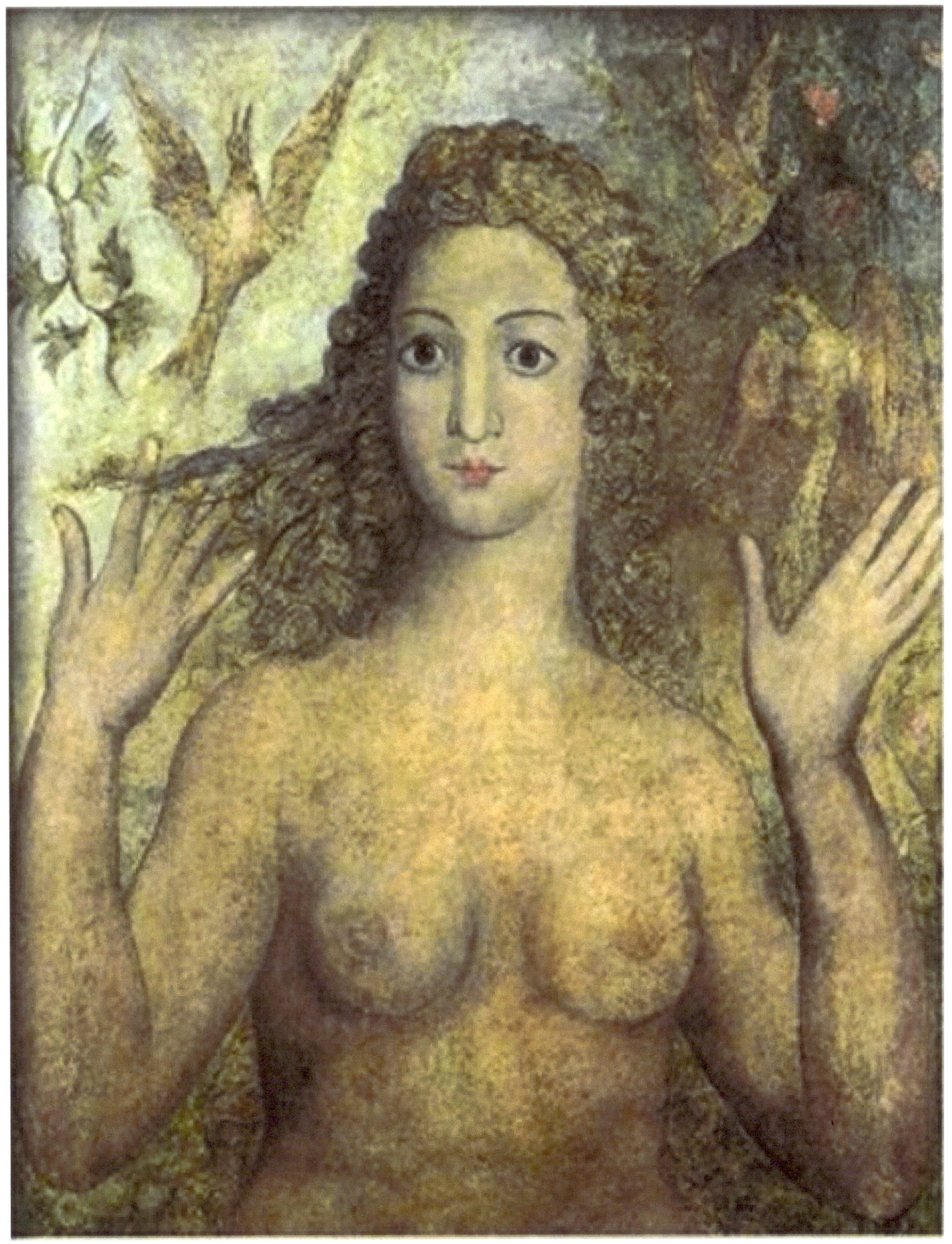
Eve by William Blake, 1810

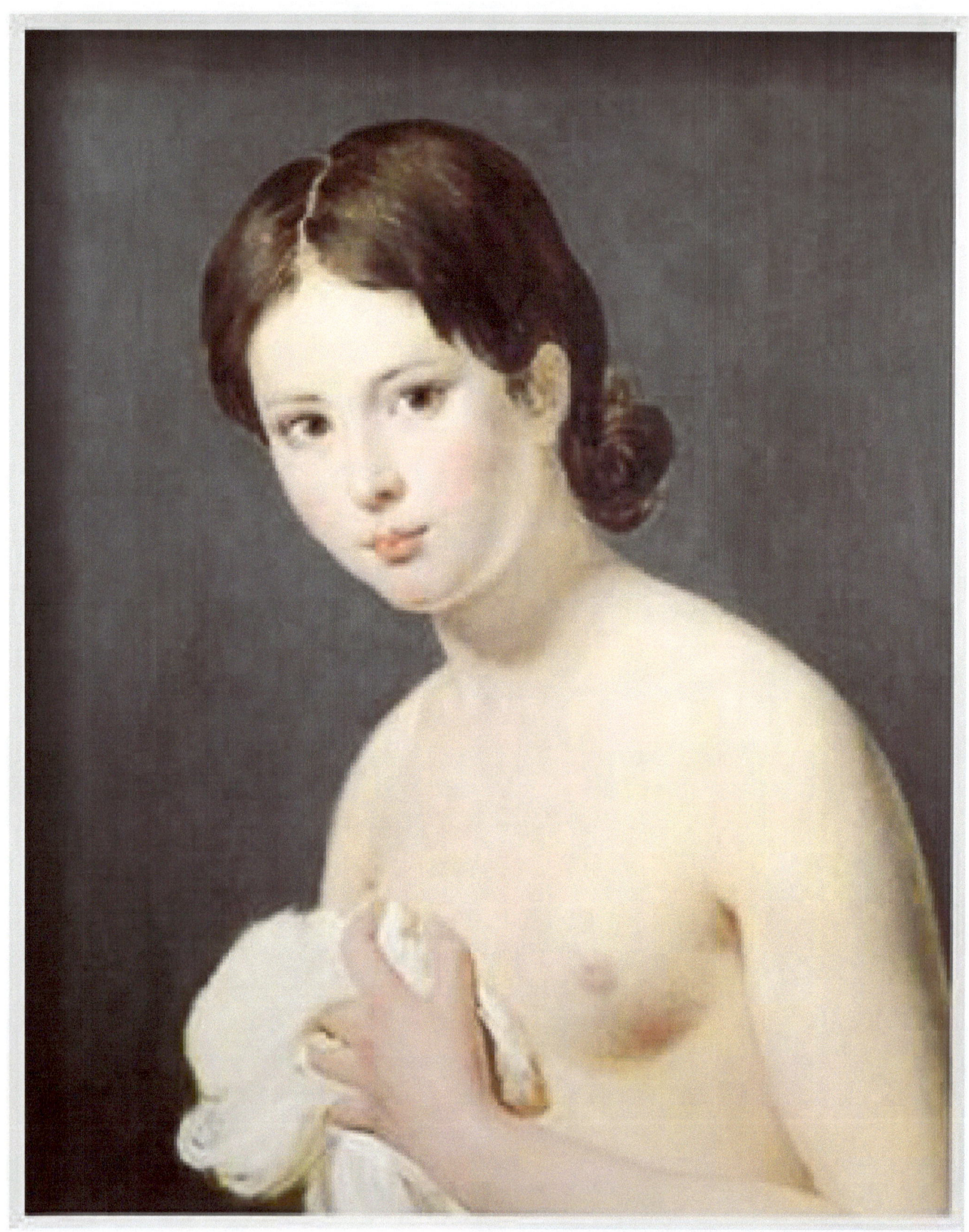

Young Girl by Jacques L. David, 1795

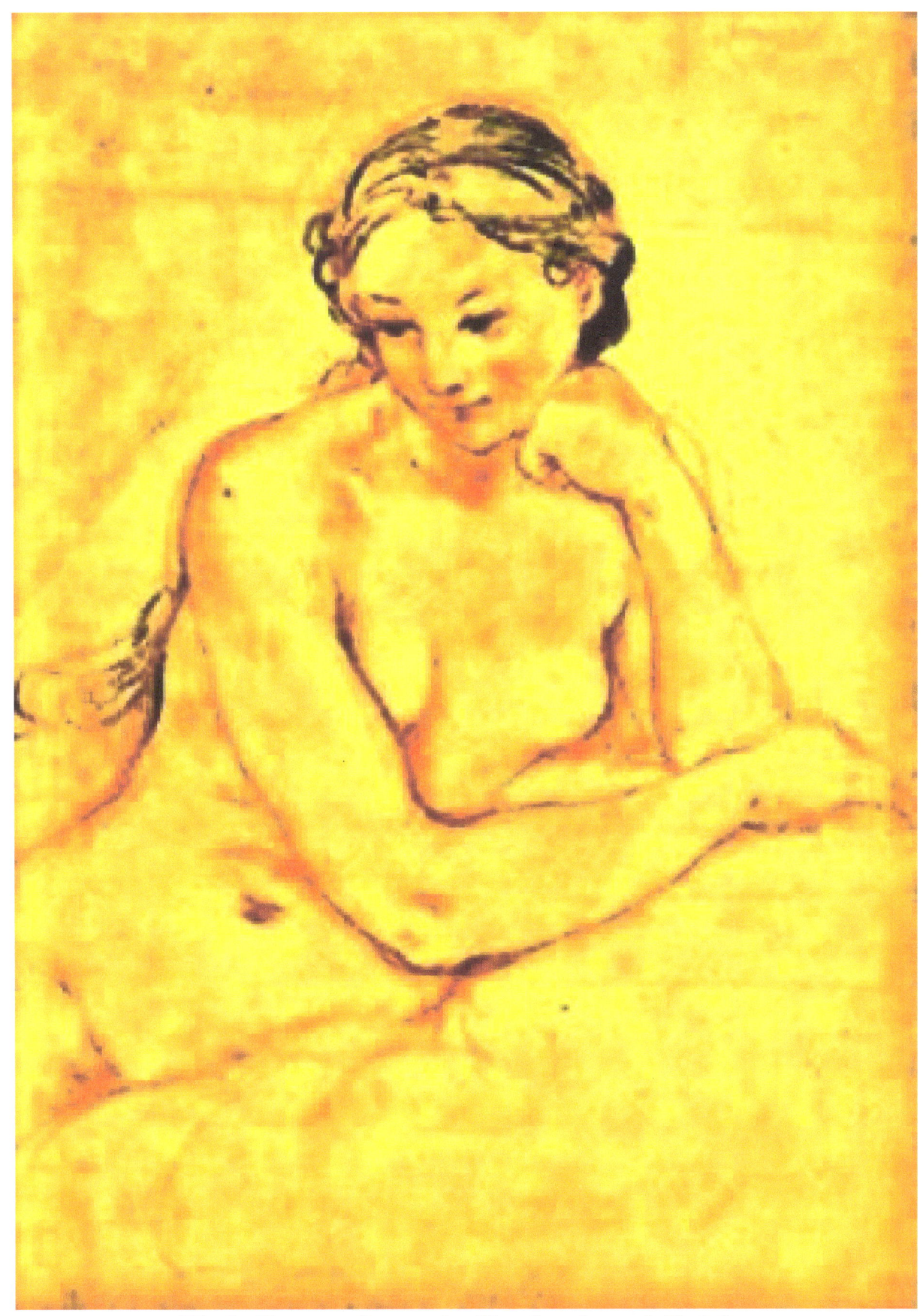
Etude Femme de nue by Charles Joseph Natoire

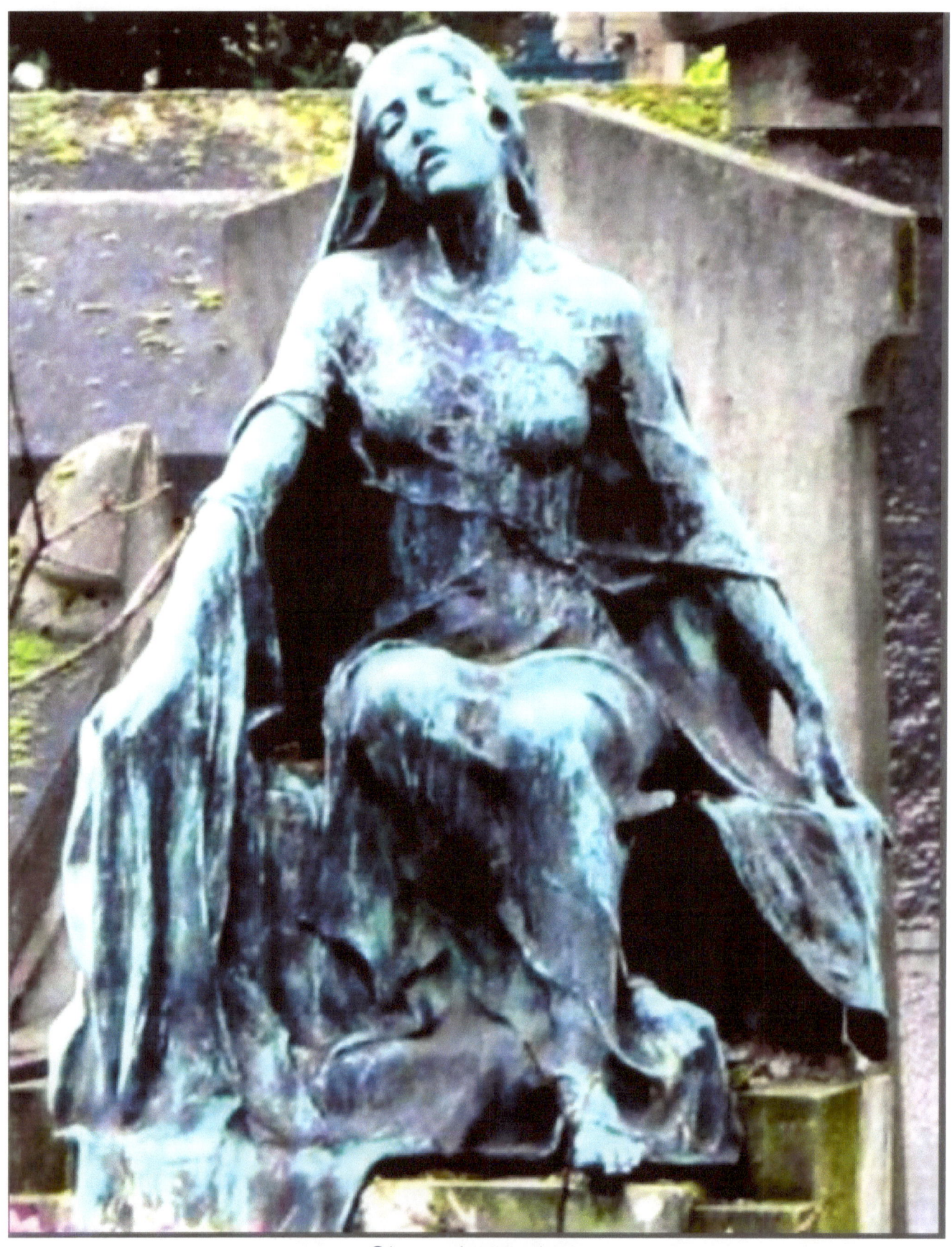
Stone at cemetery

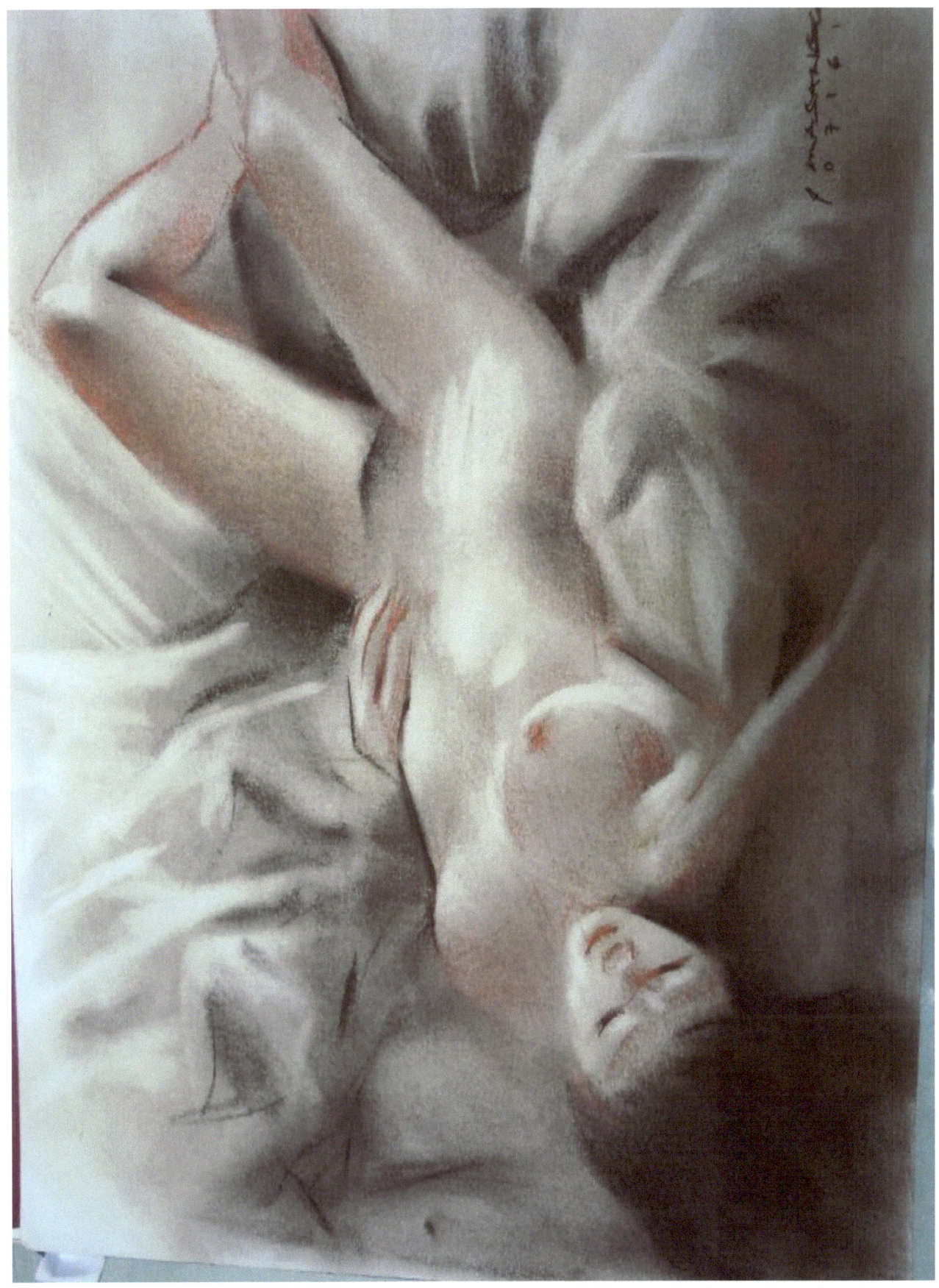

Modern Painting by Masangkay, courtesy of Edgar O. Cruz, facebook

www.ingramcontent.com/pod-product-compliance
Lightning Source LLC
Chambersburg PA
CBHW051059180526
45172CB00002B/703